# The Twilight Zone™

THERE IS A FIFTH DIMENSION
BEYOND THAT WHICH IS
KNOWN TO MAN

# IT IS A DIMENSION AS VAST AS SPACE AND AS TIMELESS AS INFINITY

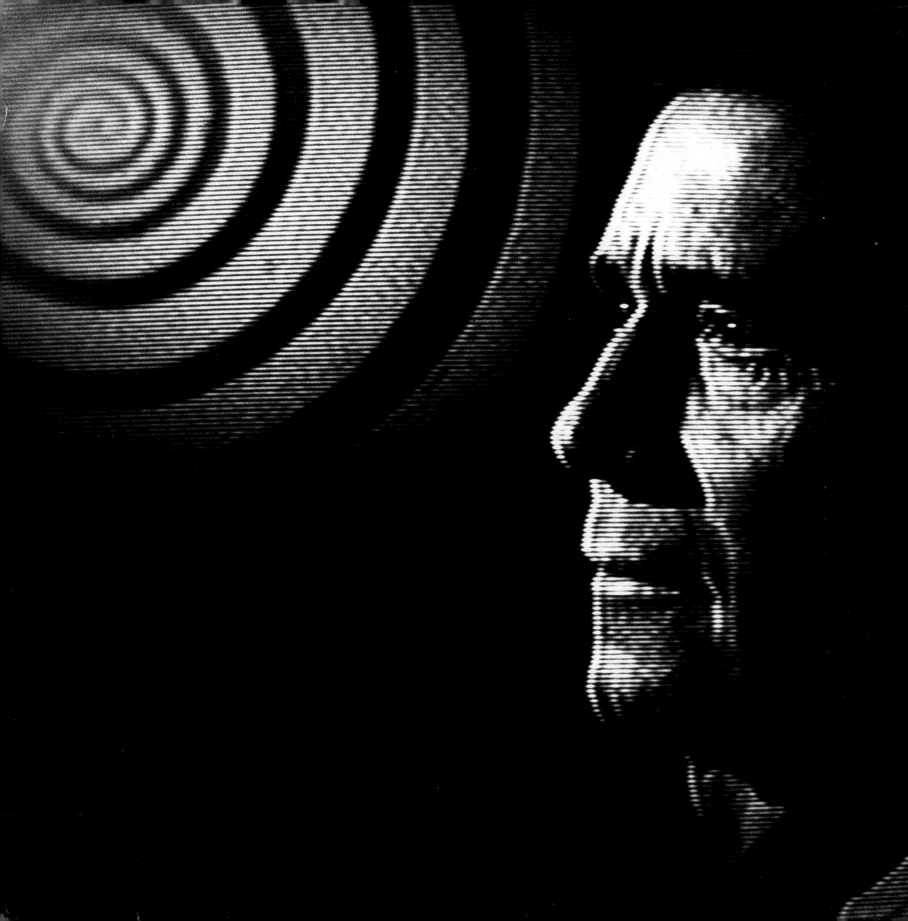

# IT IS THE MIDDLE GROUND BETWEEN LIGHT AND SHADOW

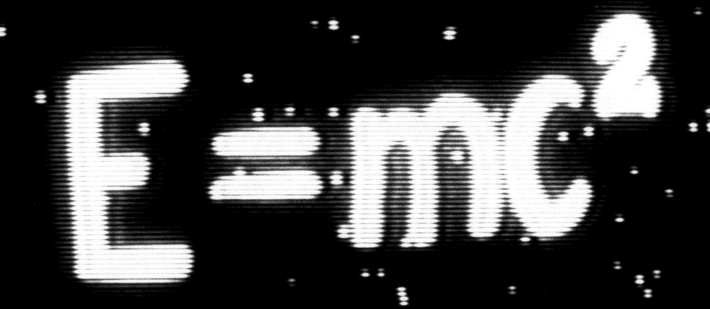

# BETWEEN SCIENCE

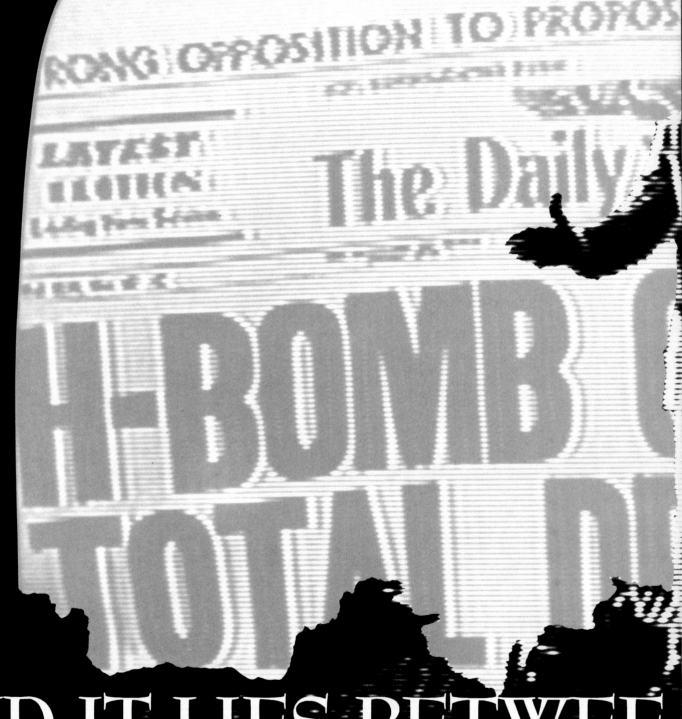

RONG OPPOSITION TO PROPOS

LATEST
ELECTION

The Daily

H-BOMB

TOTAL DE

AND IT LIES BETWEE
FEARS AND THE SUMM

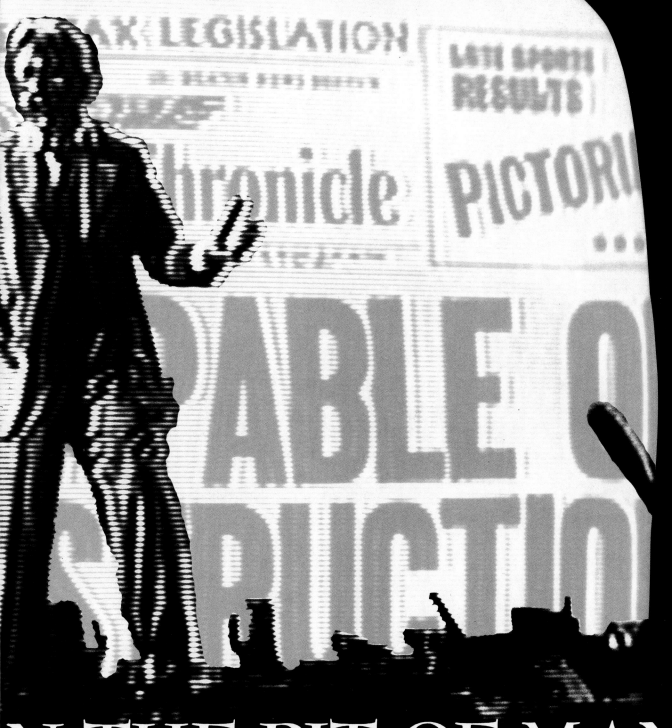

N THE PIT OF MAN'S
IT OF HIS KNOWLEDGE

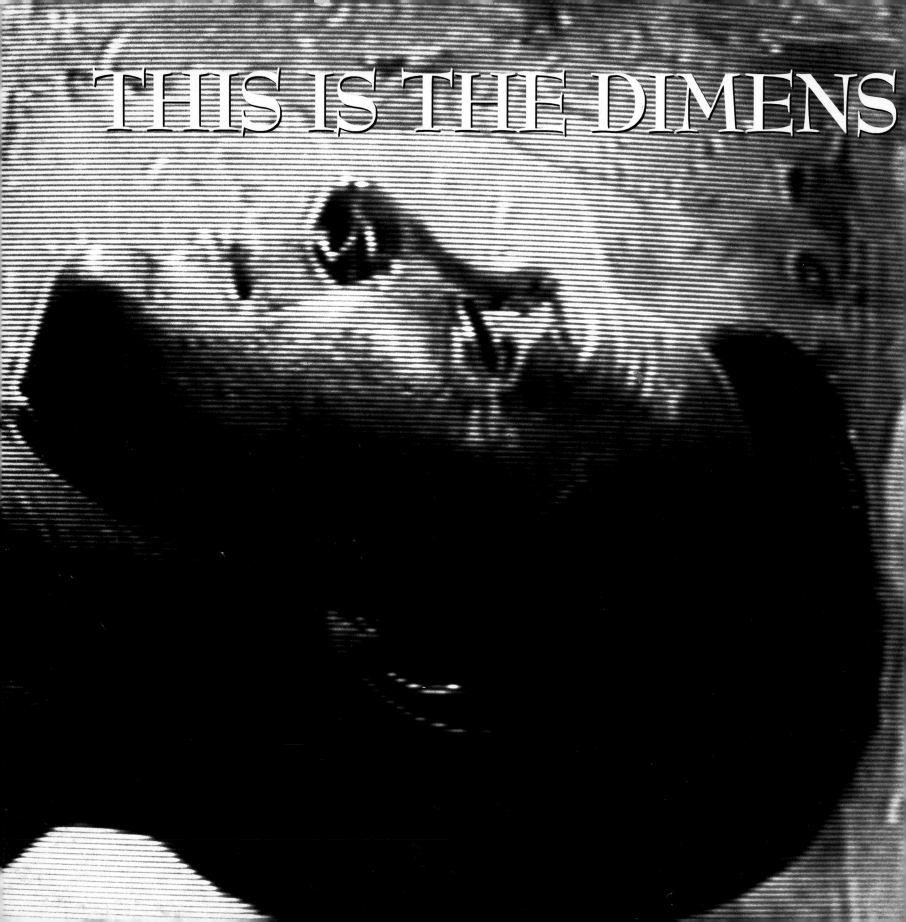

THIS IS THE DIMENS

# ION OF IMAGINATION

# IT IS AN AREA WHICH WE CALL...

# VISIONS FROM TH

By Arlen

CHRONICLE BOOKS

Afterword copyright © 1990 by Carol Serling.

"America's Twilight Zone" copyright © 1990 by J. Hoberman.

Grateful acknowledgment is made to

**VIACOM** ™

for providing access to all episodes of *The Twilight Zone.*

*The Twilight Zone* television series copyright © 1960
by CBS Inc.

"The Eye of the Beholder" copyright © 1960 by Cayuga
Productions. Copyright renewed. Reprinted with permission
from the Rod Serling Trust. All rights reserved.

"Seeking Far Horizons" by Rod Serling reprinted with per-
mission from *TV Guide*® Magazine, copyright © 1959 by
News America Publications, Inc., Radnor, Pennsylvania.

CBS ad on page 149 appears courtesy of CBS Inc. Panel from
*Weird Science,* page 151, reprinted with permission from William M.
Gaines, copyright © 1953 by Fables Publishing Co. Inc., renewed
copyright © 1981 by William M. Gaines. Photograph on page 159
by Cindy Sherman appears courtesy of Metro Pictures. Lyrics from
"Once in a Lifetime" by David Byrne, Brian Eno, Chris Frantz,
Tina Weymouth, and Jerry Harrison. Reprinted with permission
from Index Music, Inc., copyright © 1980 by Index Music
Inc./Bleu Disque Music, Inc./E.G. Music, Ltd.

*The Twilight Zone* is a trademark of CBS Inc.

Schumer, Arlen.
Visions from the twilight zone / by Arlen Schumer.
p.   cm.
ISBN 0-87701-682-8 (pbk)
ISBN: 0-87701-725-5 (cloth)
1. Twilight Zone (Television program)   I. Title.
PN1992.77.T87S38   1990
791.45′72—dc20                                89-48367
                                              CIP

Conceived, edited, and designed by Arlen Schumer
Photography: David O'Connor
Additional design and production: Harakawa/Sisco Inc.
Copyediting: Judith Dunham

This book was set in Bernhard Modern, the same
typeface used for all opening and closing credits of
*The Twilight Zone.*

Printed in Japan

Distributed in Canada by Raincoast Books,
112 East Third Avenue, Vancouver, B.C. V5T 1C8

10  9  8  7  6  5  4  3  2  1

Chronicle Books
275 Fifth Street
San Francisco, CA 94103

Everything lea

that there exists a spot in the

the real and the imaginary, the past

the communicable an

will cease to app

ds us to believe

mind from which life and death,

and the future, the high and the low,

d the incommunicable

ear contradictory.

—André Breton, *Second Surrealist Manifesto (1929)*

# INTRODUCTION

Although it shared conceptual concerns with and adapted stories from the cream of the science fiction field, *The Twilight Zone* cannot be wholly considered a science fiction television series. It wasn't horror, either—yet its shock endings are among the most horrific ever filmed for television (or motion pictures). And it would be unfair to pass the series off as pure fantasy, for it was grounded in a reality far more real and true for its day—and ours.

More than anything else, *The Twilight Zone* was surreal. The "spot in the mind" identified by French surrealist Breton was branded "the twilight zone" by American pop-surrealist Rod Serling. He put surrealism on television.

Though he might not have considered himself a surrealist, Serling does fit the criteria of enchanter, set by the surrealist poet Novalis, as "an artist of madness." In episode after episode of *The Twilight Zone*, Serling's characters questioned the very nature of their realities, both internal and external, fulfilling the surrealist desire to find a truer reality, a synthesis of the interior and exterior worlds. When people hum the opening chords of the *Twilight Zone* theme music, they are acknowledging a moment of surrealist experience as intended by the first surrealists.

And as the surrealist painters, artists, and photographers gave plastic form to the visions of the surrealist poets and writers, the visual architects of *The Twilight Zone*—its directors, cameramen, art directors, set designers, and makeup artists—provided a perfect stage for Serling's literary netherworld.

The surrealism of *The Twilight Zone* was telegraphed by its opening graphics, with their liberal borrowings from established surrealist masters: Daliesque landscapes, objects suspended Magritte-like in space. Coupled with Serling's singular vocal delivery and Marius Constant's theme music, these graphics made for memorable show openings and foreshadowed the series' interior photography.

The distinctive photographic "look" of *The Twilight Zone* operated on two levels: the first, as visual interpretation of its subjects' inner torment, suspended between reality and unreality; the second, as metaphor for the television image itself. By utilizing graphic close-ups, angular cropping, and chiaroscuro lighting to reduce images to their most basic, iconic forms, and placing actors in sparse, simple set designs (like the props they often turned out to be), these pared-down, stark elements made the television set work as a kind of electronic puppet theater, befitting the essentially stagelike nature of the productions: a series of two-act plays filmed for television.

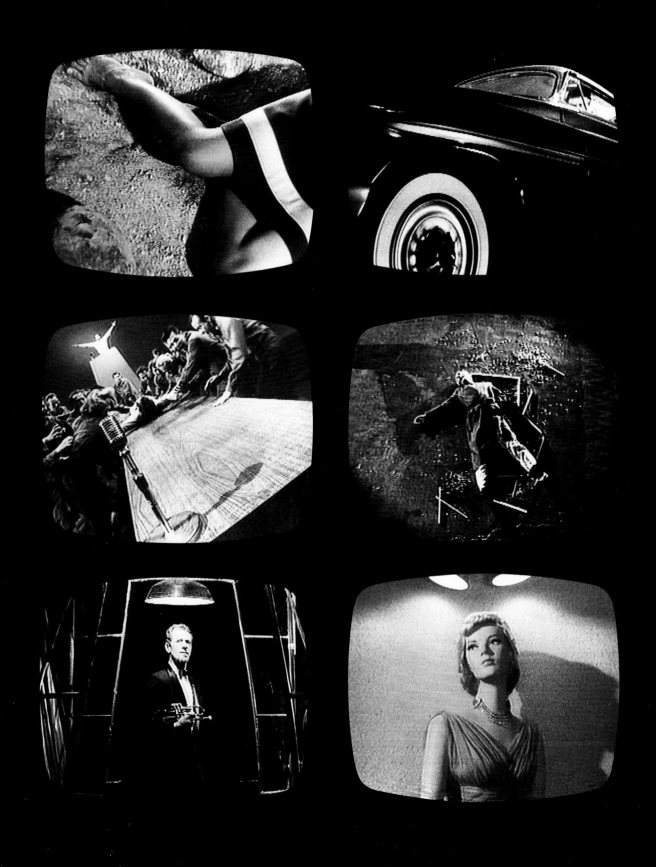

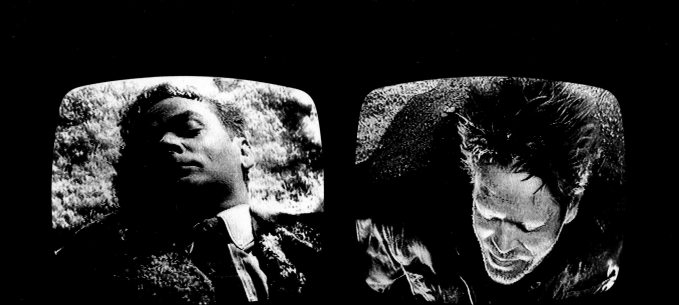

This surreal quality of television theater, like that of a shadow box within which images are played, is most dramatically evident in "The Eye of the Beholder," a classic Serling script capped by perhaps *Twilight Zone*'s most unforgettable shock ending. The stunning camerawork and lighting designs by director of photography George T. Clemens and the choreographic direction by Douglas Heyes demonstrate that, like their contemporary, Ernie Kovacs, *Twilight Zone*'s imagists understood how best to exploit the limitations of the television medium. The small screen required simpler imagery and even less background detail (hence the supremacy of the close-up and its correlative, the talking head), unlike the larger-than-life movie screen, where saturated color and lush location photography served to reinforce the illusion of reality. "*Twilight Zone* was really designed for the TV set; a lot of shows were not," recalls Heyes. "*Twilight Zone* was stylized to be exactly what was going to be on the tube. The compositions that we'd choose, even on the exteriors, would be tight, ones that would carry from across the living room. Clemens, of course, had that instinctive sense also, to make them work for black and white television."

Clemens had come out of retirement in 1959 from a background in cinematography (including the creation of the lighting and makeup transformation of Fredric March in the 1932 version of *Dr. Jekyll & Mr. Hyde*) to become director of photography throughout *Twilight Zone*'s network run (131 out of 156 episodes from 1959 to 1964). A classic Hollywood craftsman, Clemens was painstakingly devoted to the series. "Everything has got to be just right," he told *Variety* after winning an Emmy in 1961 for his *Twilight Zone* work. "We shoot 15,000 to 20,000 feet an episode to get 1,800 feet of what we want for the twenty-three minutes on the air." When early in its production there was pressure on Serling to switch *Twilight Zone* to the new color photography, Clemens objected vehemently. He remembers telling Serling, "I can't give you what we feel is the *Twilight Zone* feeling in color as I could in black and white."

Capturing this "*Twilight Zone* feeling" is what *Visions from The Twilight Zone* is all about. It is the "story" of *The Twilight Zone* in its own words and pictures, juxtaposed from different episodes culled from the series' five seasons. (Juxtaposition was at the core of *The Twilight Zone* as it was in surrealism, described by poet Pierre Reverdy in 1918 as "the bringing together of two realities which are more or less remote. The more distant and just the relationship of these realities, the stronger the image—the more emotive power and poetic reality it will have.") Through such juxtapositioning, *The Twilight Zone* is treated as a cohesive body of work, crafted by many sensibilities but united under one—Serling's—vision.

"Rod's pattern was not only communicable to the people who made his pictures," remembers Buck Houghton, *Twilight Zone*'s original producer (1959–62), "it was communicable to other writers," chief among them Richard Matheson and the late Charles Beaumont. They shared a flair for poetic dialogue that was most dominant in Serling's writing; actor Dan Duryea once commented that he couldn't remember the last time he had recited poetry without feeling self-conscious about it. Ayn Rand, also a writer of stylized dialogue, praised Serling at the time, remarking that he wrote ". . . some of the most beautiful dialogue that has ever issued forth from the mouths of TV characters."

Serling's humanism, compassion, and respect for man's potential can be compared with that of Frank Capra's (the half-hour fantasy sequence in *It's a Wonderful Life* is a proto-*Twilight Zone* episode). Both men tried to raise the consciousness of their audiences through commercial mediums, and were chided by critics for lapsing into sentimental moralizing and soapbox reform. But if Serling was the Capra of TV, he was also the medium's Orson Welles; he exercised total creative control over all facets of *The Twilight Zone*, making him a true television *auteur*.

Its totality and cohesiveness make *The Twilight Zone* Serling's magnum opus, an oeuvre that communicated to an entire generation. "Rod had some sort of common touch," Houghton adds, "whereby a sympathy for the common man and the problems that he dealt with and faced and won and lost was communicated to an awful lot of people." Serling's surrealistic concept of alternate realities—of seeing beyond the ordinary—paved the way for, and

influenced the Sixties by implicitly (and often explicitly) stating that things don't have to be the way they are, that authority and the status quo must always be challenged and bettered.

*The Twilight Zone* is a legacy that continues to teach, entertain, and inspire; it is a measure of that legacy that Serling was able to surmount the obstacles inherent in commercial television and touch peoples' imaginations with more impact than any television writer of our time. Serling and Company's twenty-three-minute meditations on a wide spectrum of philosophic concerns, from the political to the metaphysical, have so penetrated the mass culture that now, over thirty years after its debut, "the twilight zone," the concept, has become a psychological buzzword, unearthing automatic associations of the existential and the surreal in the commonplace.

*Visions from The Twilight Zone* illustrates the core concepts and pop philosophies that are the zeitgeist of *The Twilight Zone* by pairing them with images that, though originally shot in 35mm film, were transmitted and ostensibly perceived as *television* images. This perceptual context was maintained by photographing off a generic black and white TV screen (250 scanlines wide, as opposed to today's color receivers, which contain more than twice as many) and then printing to approximate the "look" of black and white television.

Think of *Visions* as a museum of *The Twilight Zone*, its ideas and images selected and arranged by its curator, and herein "submitted for your approval ..."

Arlen Schumer

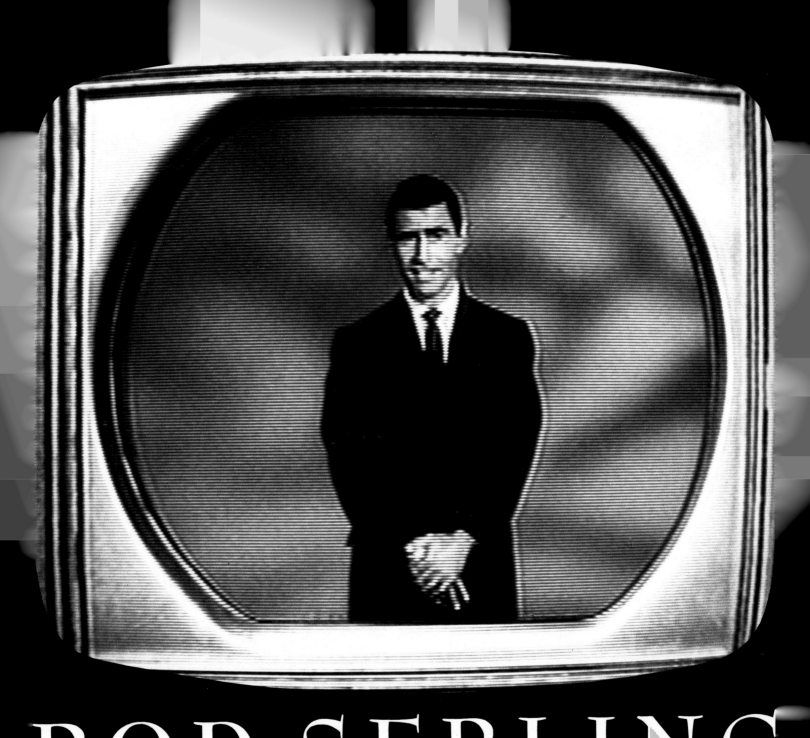

ROD SERLING

# THE TWILIGHT ZONE

**...is what it implies. That shadowy area of the almost-but-not-quite; The unbelievable told in terms that can be believed.**

Here's what *The Twilight Zone* is: it's an anthology series, half hour in length, that delves into the odd, the bizarre, the unexpected.

Here's what *The Twilight Zone* isn't: it's not a monster rally or a spook show. It probes into the dimension of imagination but with a concern for taste and for an adult audience too long considered to have IQs in negative figures.

Each show is a carefully conceived and wrought piece of drama, cast with competent people, directed by creative, quality-conscious guys, and shot with an eye toward mood and reality. There will be nothing formula'd, nothing telegraphed, nothing so nostalgically familiar that an audience can join actors in duets.

The exciting thing about our medium is its potential, the fact that it doesn't have to be imitative. What it can produce in terms of novelty and ingenuity has barely been scratched. This is a medium that can spread out, delve deep, probe fully and reach out experimentally to whole new concepts. The horizons of what it can do and where it can go stretch out beyond vision.

And that's what we're trying to do with *The Twilight Zone*. We want to tell stories that are different. We want to prove that television, even in its half-hour form, can be both commercial and worthwhile. The half-hour film can probe effectively, dramatize and present a well-told and well-filmed story; at the same time, perhaps only as a side effect, a point can be made that the fresh and untried can carry more infinite appeal than a palpable imitation of the already proved.

*The Twilight Zone* is a wondrous land of the very different. No luggage is required for the trip. All that the audience need bring is imagination.

—Excerpted from "Seeking Far Horizons," *TV Guide,* November 7, 1959

# ROD SERLING

# The Twilight Zone™

The place is here…the time is now…

And the journey

Into the shadows

That we're about to watch

Could be our journey

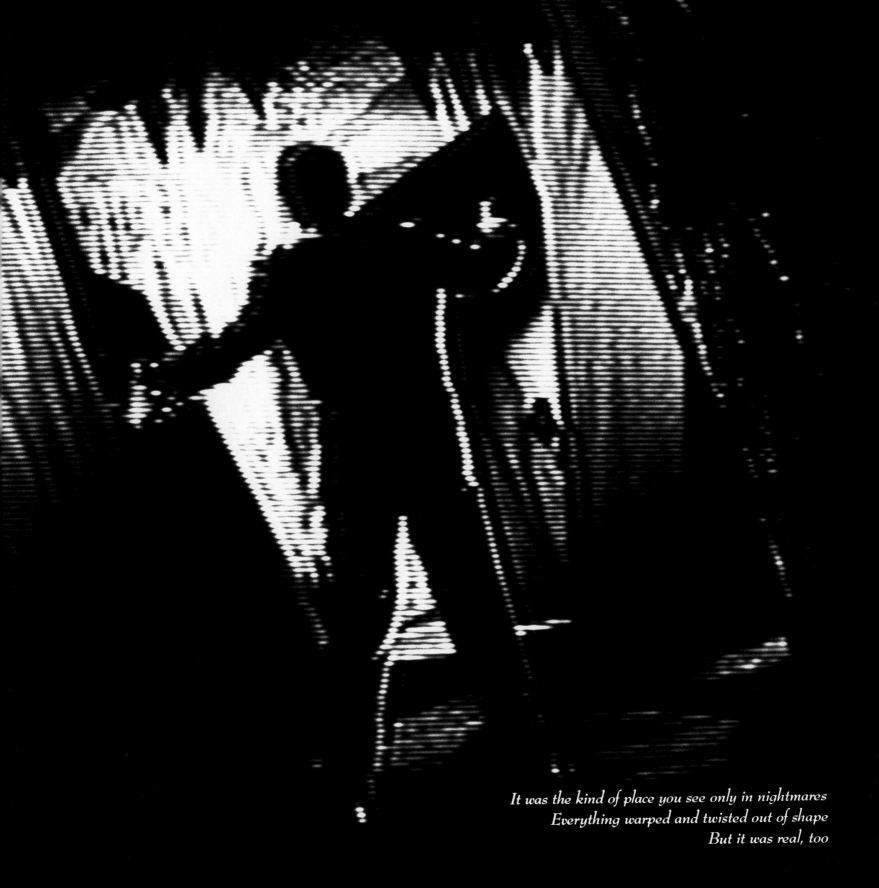

*It was the kind of place you see only in nightmares*
*Everything warped and twisted out of shape*
*But it was real, too*

27

You're in a

Kind of limbo

You're neither

Here nor there

You're in the middle between

The two: the real and the shadow

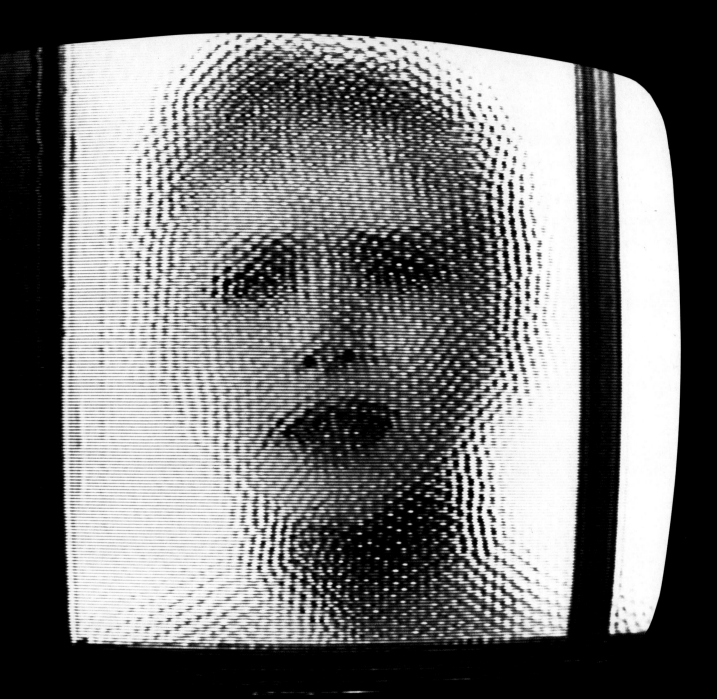

We exist, of course, but how?
In what way?

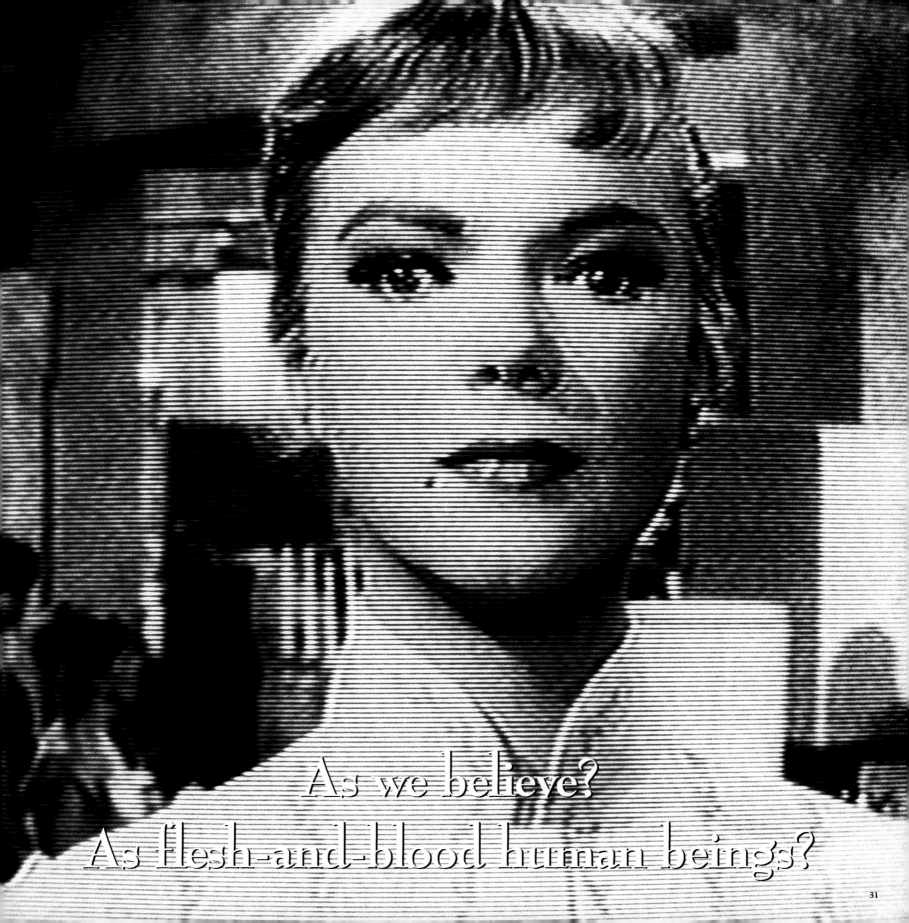

As we believe?
As flesh-and-blood human beings?

How can you be REAL when you're made of WOOD?

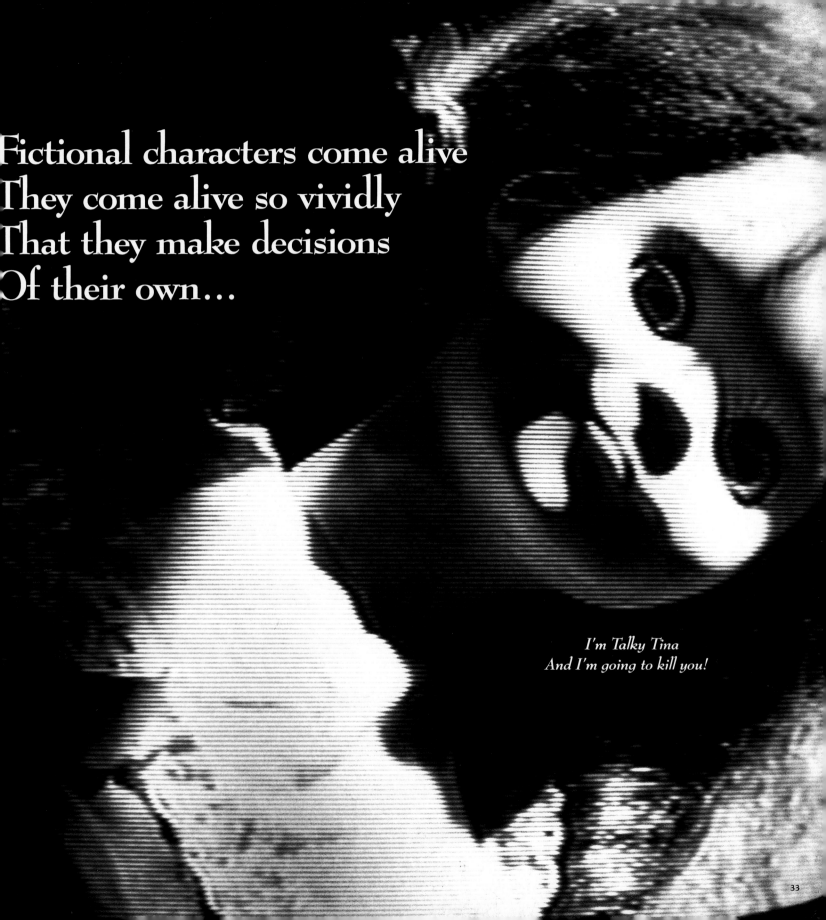

Fictional characters come alive
They come alive so vividly
That they make decisions
Of their own…

*I'm Talky Tina
And I'm going to kill you!*

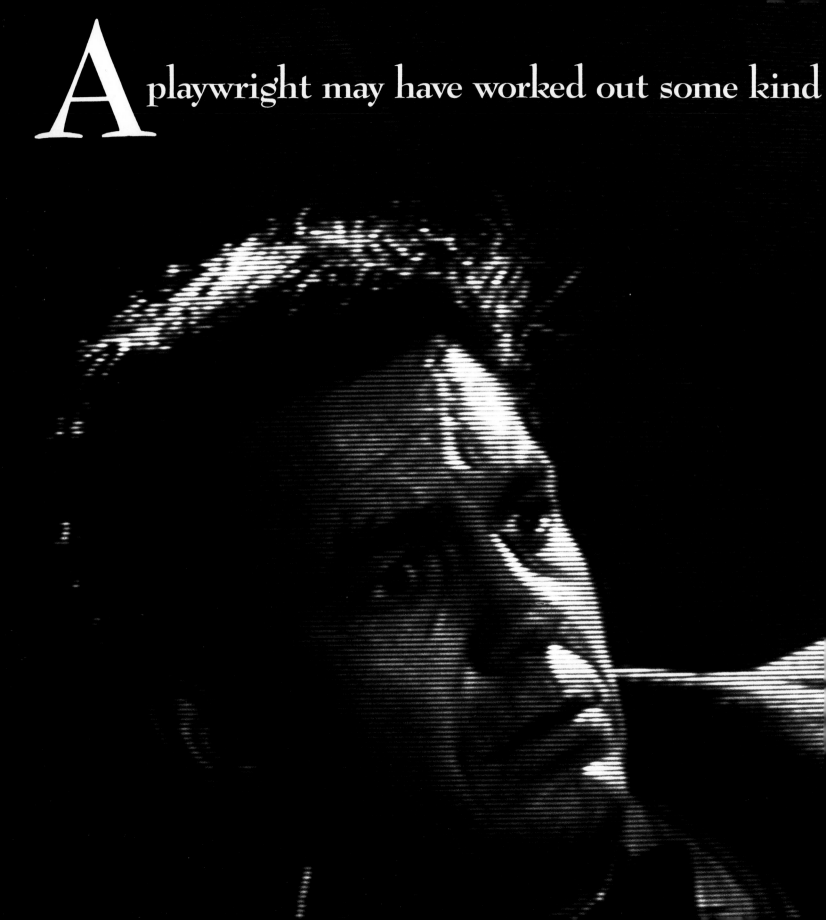

A playwright may have worked out some kind

ove for them but  THEY REFUSE TO DO IT!

I'VE BEEN
REMEMBERING

ABOUT SOMETHING
I READ OR
HEARD ABOUT
A LONG TIME AGO

ABOUT DIFFERENT
PLANES OF
EXISTENCE

ABOUT TWO
PARALLEL WORLDS
THAT EXIST
SIDE BY SIDE

AND EACH OF US
HAS A
COUNTERPART
IN THIS WORLD

AND SOMETIMES
THIS COUNTERPART
COMES INTO
OUR WORLD

AND IN ORDER
TO SURVIVE IT
HAS TO TAKE OVER

REPLACE US

MOVE US OUT
SO THAT IT
CAN LIVE

I'M YOUR

MEMORY

YOUR

CONSCIENCE

I'M EVERY ONE

OF YOUR

ASPIRATIONS

AND

RECOLLECTIONS

I'M EVERY ONE

OF YOUR

FAILURES AND

DEFEATS

I ALSO WEAR

THE WREATHS

OF ALL YOUR

VICTORIES

I'M WHAT YOU

CALL THE

ALTER EGO

WE HAVE

One that we wear and the

# TWO FACES

## other that we keep hidden

# JUST HOW NOR

Just who are the people we nod our

# MAL ARE WE?

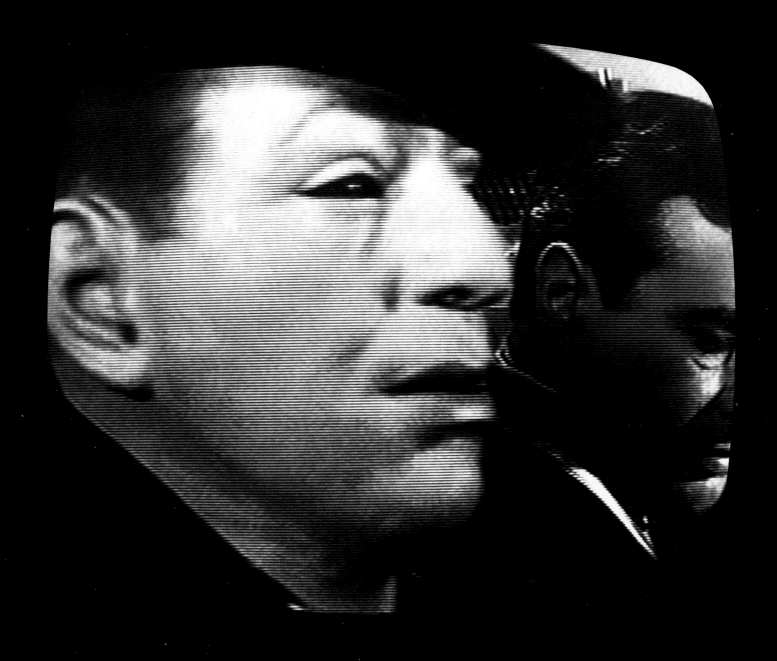

## hellos to as we pass on the street?

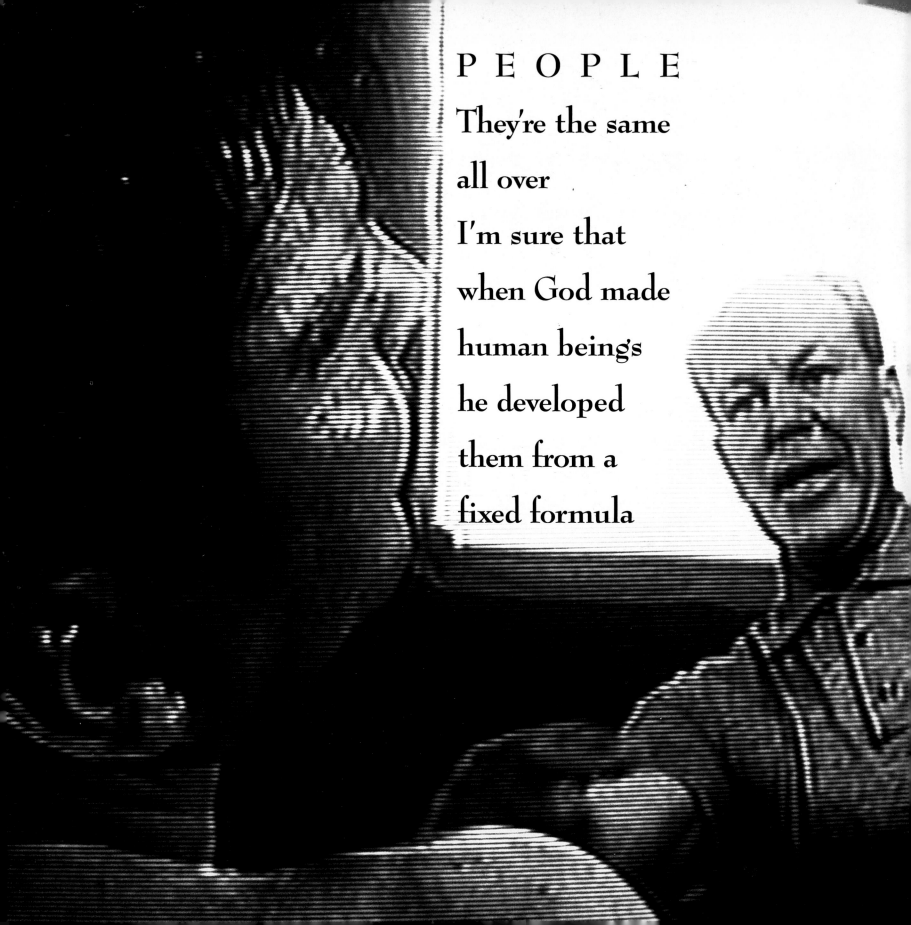

# PEOPLE

They're the same
all over
I'm sure that
when God made
human beings
he developed
them from a
fixed formula

AS LONG
as they've got
minds and hearts
that means
they've got souls
That makes them
PEOPLE
and people are
ALIKE

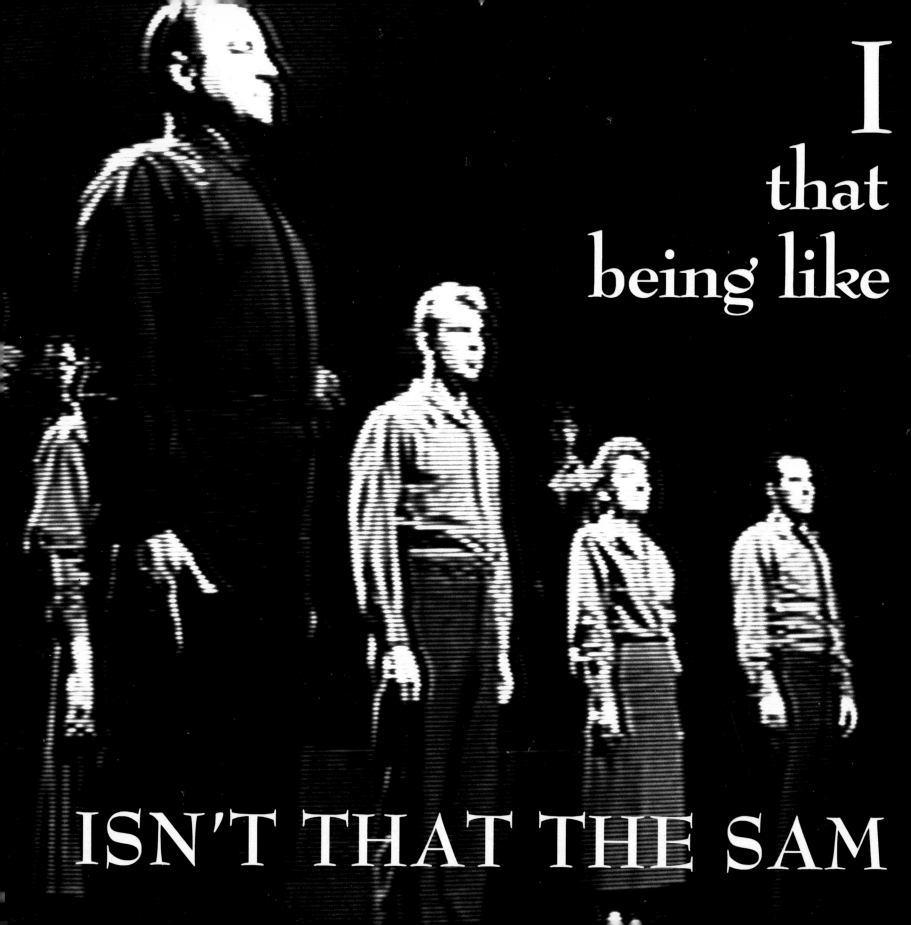

I that
being like

ISN'T THAT THE SAM

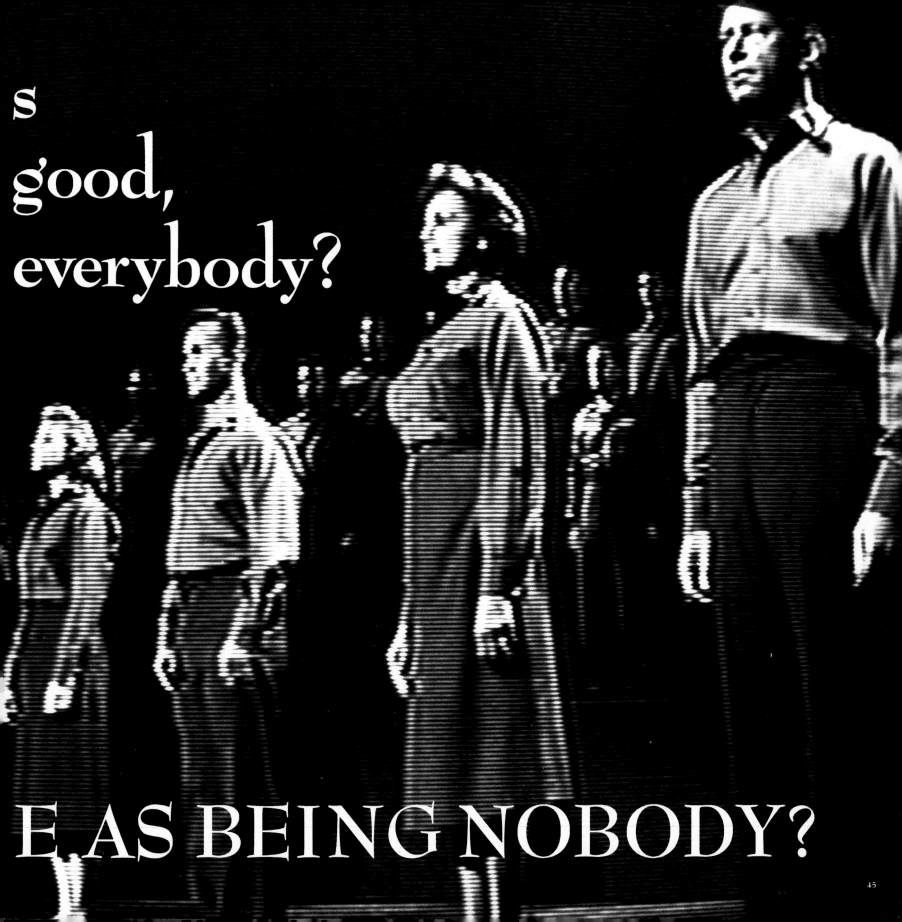

s
good,
everybody?

E, AS BEING NOBODY?

When
everyone is beautiful
NO ONE WILL BE

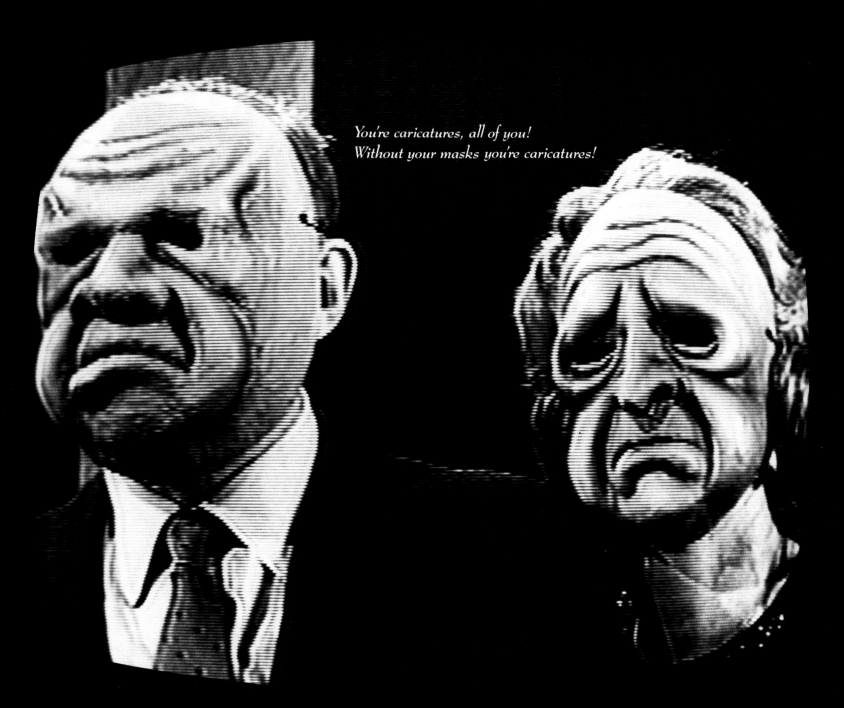

*You're caricatures, all of you!*
*Without your masks you're caricatures!*

# BECAUSE WITHOUT UGLINESS
# There can be no beauty

# HE BEHOLDER"

Written by
## ROD SERLING

Directed by
## DOUGLAS HEYES

Produced by
## BUCK HOUGHTON

Director of Photography
## GEORGE T. CLEMENS

## MAKEUP BY WILLIAM TUTTLE

Art Direction by George W. Davis and Phil Barber
Set Decorations by Henry Grace and H. Web Arrowsmith

Nurse?                                    Time for your sleeping medicine, honey.

Is it night already?

It's nine-thirty.

Oh—what about
the day?

What about it?

Well, was it a beautiful
day? And was it warm?
Was the sun out?

It was kinda warm.

Yes, and clouds? Were
there clouds in the sky?

I suppose there were.
I never was much for
staring up at the sky.

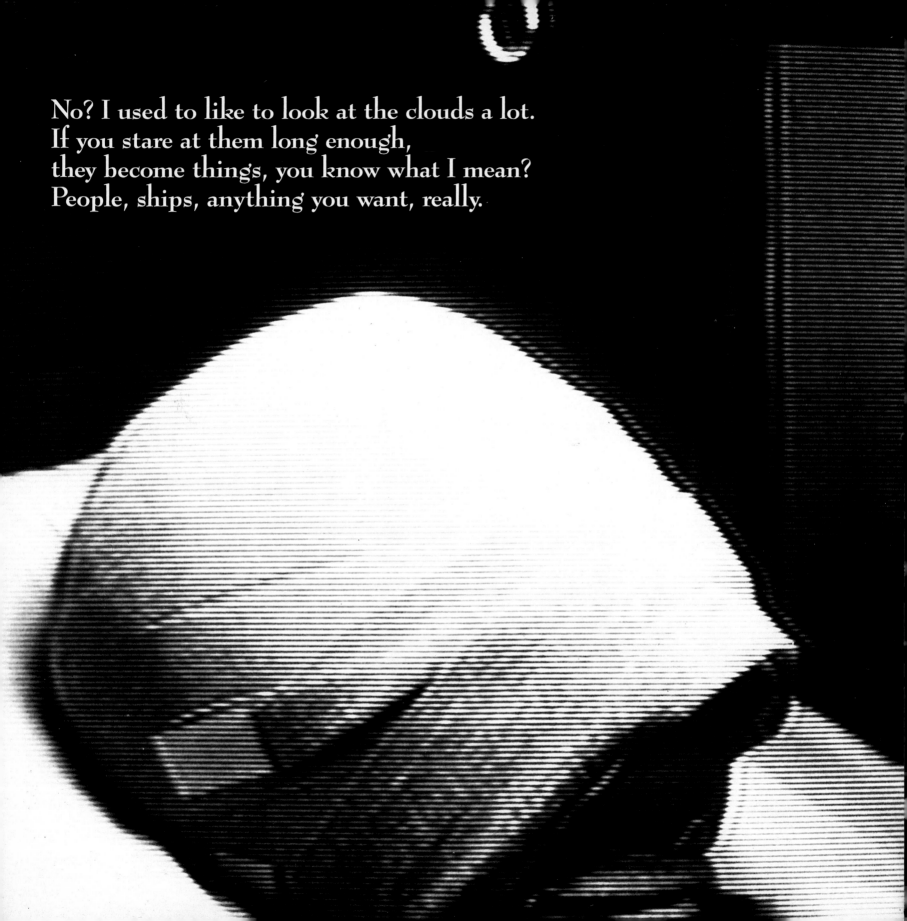

No? I used to like to look at the clouds a lot.
If you stare at them long enough,
they become things, you know what I mean?
People, ships, anything you want, really.

It's time to take your temperature now.

Oh, please, one more thing, Nurse?          Well?

When will they take the bandages off?
How long?                          Until they decide
whether or not they can fix your face.

Oh. I guess it's...
pretty bad, isn't it?          I've seen worse.

Well, yes, but it's pretty bad, isn't it?

Oh, I know it's pretty bad.

Ever since I can remember . . .

ever since I was a little girl,

people have turned away

when they looked at me.

Funny . . . the very first thing

I can remember is . . .

. . . another little girl screaming

when she looked at me.

Oh, I never really wanted

to be beautiful, you know?

I mean, I never wanted to look like a painting.

I never even wanted to be loved, really.

I just wanted people not to scream

when they looked at me.

When, Nurse? When, when will they take
the bandages off?

Maybe tomorrow.

Maybe the next day.

Now hush.

You've been waiting so long now,
it doesn't really make much difference whether
it's two weeks or days now, does it?

Dr. Bernardi. Evening report on Patient 307. No temperature change. Resting comfortably.

Thank you, Nurse. I'll be down later.

Ever see her face? 307?

Indeed I have. If it were mine, I'd bury myself in a grave someplace. Poor thing. Some people want to live no matter what!

Cigarette?

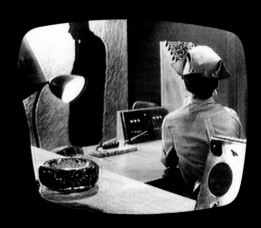

SUSPENDED IN TIME AND SPACE FOR A MOMENT, YOUR INTRODUCTION TO MISS JANET TYLER, WHO LIVES IN A VERY PRIVATE WORLD OF DARKNESS; A UNIVERSE WHOSE DIMENSIONS ARE THE SIZE, THICKNESS, LENGTH OF A SWATHE OF BANDAGES THAT COVER HER FACE. IN A MOMENT WE'LL GO BACK INTO THIS ROOM, AND ALSO IN A MOMENT WE'LL LOOK UNDER THOSE BANDAGES, KEEPING IN MIND, OF COURSE, THAT WE'RE NOT TO BE SUR-PRISED BY WHAT WE SEE. BECAUSE THIS ISN'T JUST A HOSPITAL. AND THIS PATIENT 307 IS NOT JUST A WOMAN. THIS HAPPENS TO BE THE TWILIGHT ZONE. AND JANET TYLER, WITH YOU, IS ABOUT TO ENTER IT!

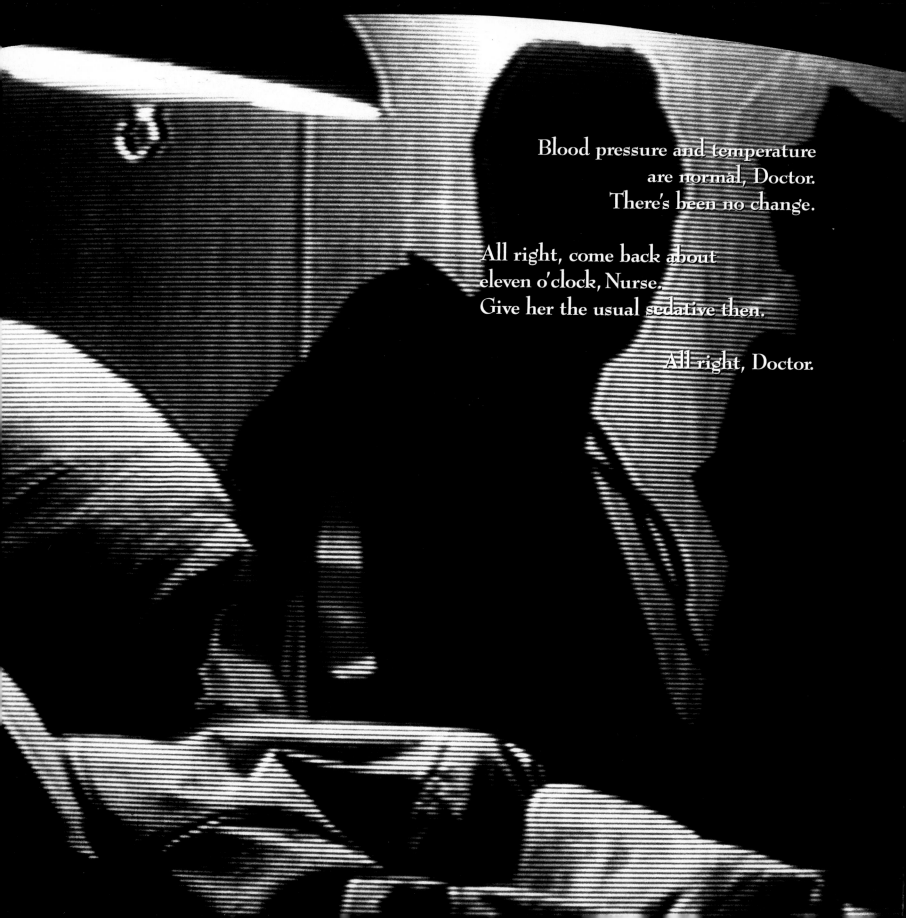

Blood pressure and temperature
are normal, Doctor.
There's been no change.

All right, come back about
eleven o'clock, Nurse.
Give her the usual sedative then.

All right, Doctor.

Well, it's warm this evening, Miss Tyler.

Yes, I thought it was, but
I couldn't be sure.

Well, it's very warm.
You can take my word for that.
We'll have those bandages off you very soon.
I expect you're pretty uncomfortable.

Well, I'm used to bandages on my face.

I have no doubt...
This is your ninth visit here. It is the ninth?

The eleventh.
You know, sometimes I think
I've lived my whole life inside of
a dark cave with walls of gauze.
And the wind that blows in
through the mouth of the cave
smells of ether and disinfectant.

Because there's a kind of a comfort
living inside this cave. Wonderfully...
private. Nobody can ever see me.

It's hopeless, isn't it, Doctor?
I'll never look any differently.

Well, that's hard to say. Up to now, you haven't responded to the shots, the medications, any of the proven techniques. Frankly, you've stumped us, Miss Tyler. Nothing we've done so far has made any difference at all. However, we're very hopeful for what this last treatment may have accomplished.

There's no telling, of course, until we get the bandages off. I'm sorry your case is not one that we could've handled with plastic surgery, but your bone structure, flesh type... many factors prohibit the surgical approach.
Your eleventh visit...

No more after this, are there, Doctor? No more tries?

Eleven is the mandatory number of experiments. We're not permitted to do any more after eleven.

Now what, Doctor?

Well, you're kind of jumping the gun, aren't you, Miss Tyler?
You may very well have responded to these last injections.
There's no way of telling 'til we get the bandages off.

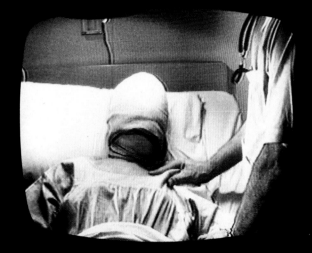

And if I haven't responded—then what?

Then there are alternatives.

Like?

Don't you know?

Yes, I know.

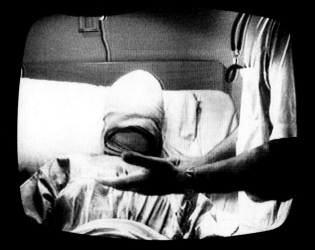

You realize, of course, Miss Tyler,
why these rules are in effect.
Each of us is afforded as much opportunity
as possible to fit in with society.
In your case, think of the time and money
and the effort expended to make you look—

Look like what, Doctor?

Normal. The way you'd like to look.

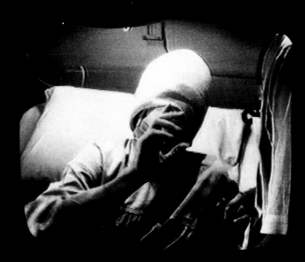

Doctor? Doctor, may I walk outside?
Please, may I?
May I just go and sit in the garden?
Just for a little while?
Just . . . just to feel the air?
J-Just to smell the flowers?

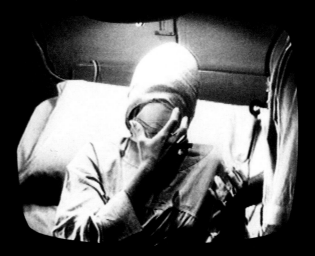

Just . . . just to make believe I am normal?
If—if I sit out there in the darkness,
then the whole world is dark,
and I'm more a part of it like that.

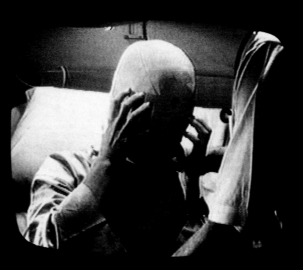

Not just one grotesque, ugly woman
with a bandage on her face,
with a special darkness all her own.

I WANT TO BELONG!
I WANT TO BE LIKE EVERYBODY!
PLEASE, DOCTOR! PLEASE HELP ME!

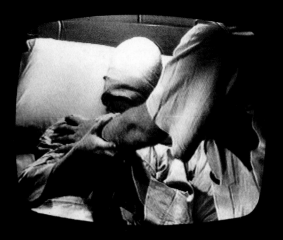 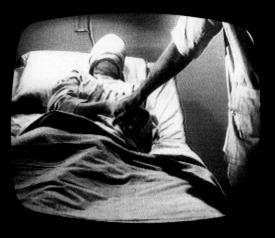 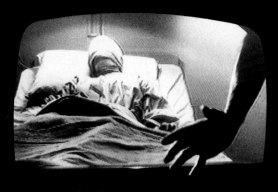

There are many others
who share your misfortune,
people who look much as you do.

One of the alternatives,
just in the event that this last
treatment is not ... successful...

... is simply to allow you to move
into a special area
in which people of your kind
have been congregated.

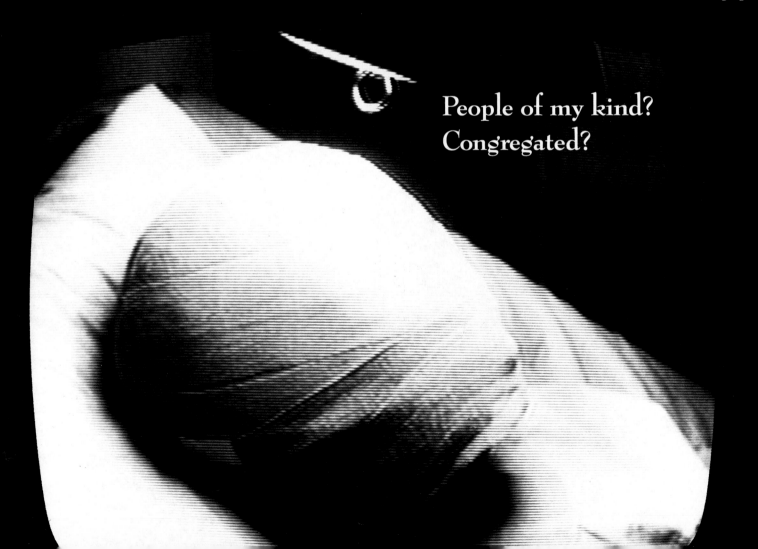

People of my kind?
Congregated?

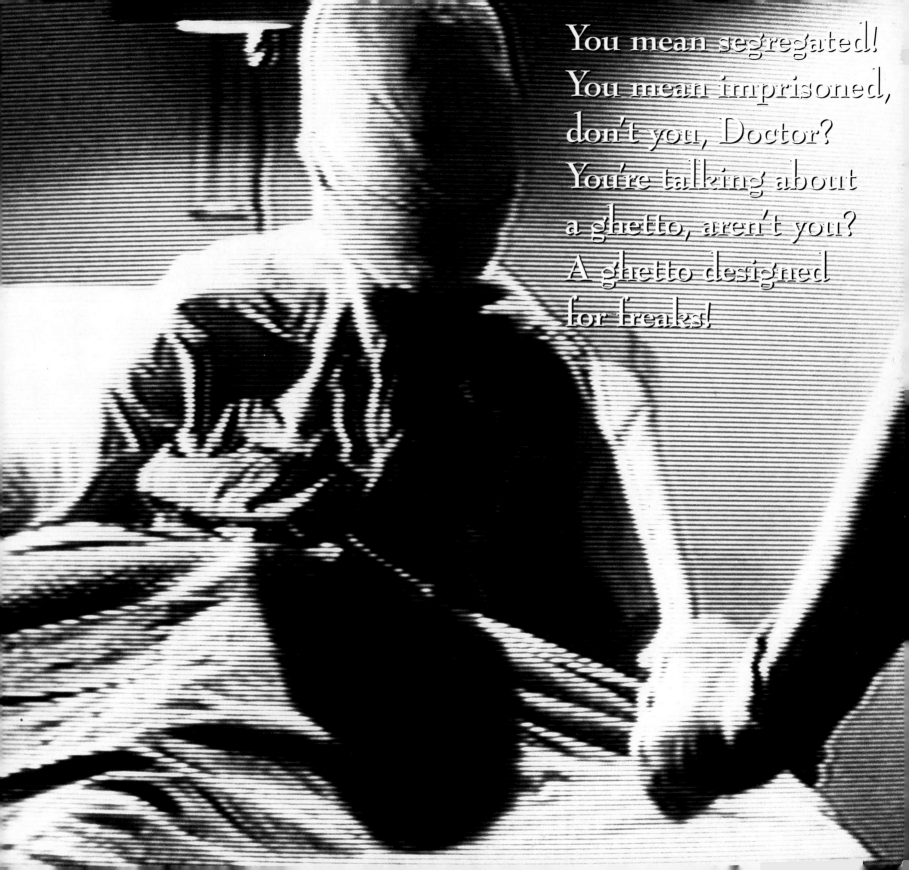

You mean segregated!
You mean imprisoned,
don't you, Doctor?
You're talking about
a ghetto, aren't you?
A ghetto designed
for freaks!

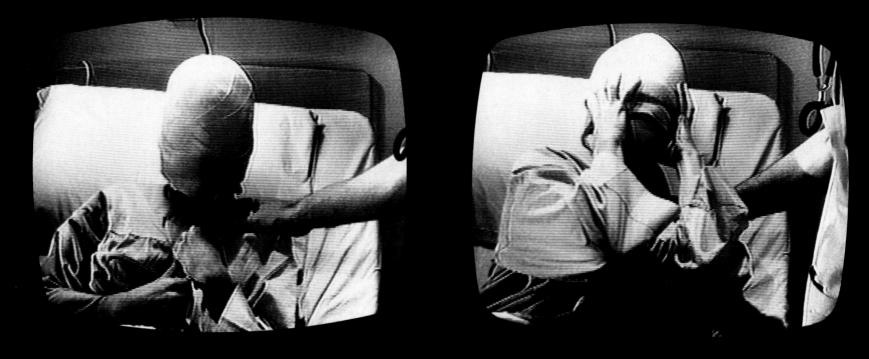

Your presence here in this hospital is proof of that. It's doing all it can for you. But you're not being rational, Miss Tyler. Now you know you can't expect to live any kind of a life among... normal people.

I could try. I—could wear... I wouldn't bother anybody. I'd just g

The State is not God! It hasn't the right to penalize somebody for an accident of birth! It hasn't the right to make ugliness a crime!

mask, or—or this bandage, or—
my own way. I'd get a job. Any job...

Who are you people anyway? What is this State?
Who makes all these rules and conditions and statutes
for people who are different to stay away from the people
who are normal? The State isn't God, Doctor.

Miss Tyler, please!

Miss Tyler! Miss Tyler,
stop this immediately!

I feel the night out there!
I feel the air!
I can smell the flowers!

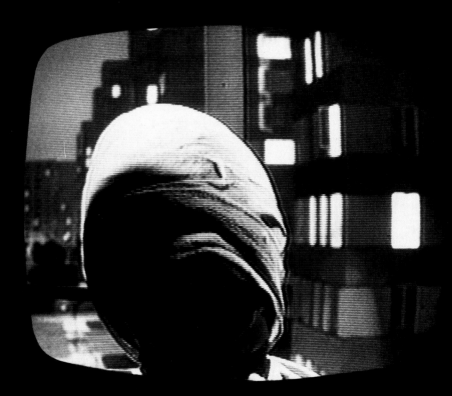

Oh—oh please...oh please,
please take this off me...

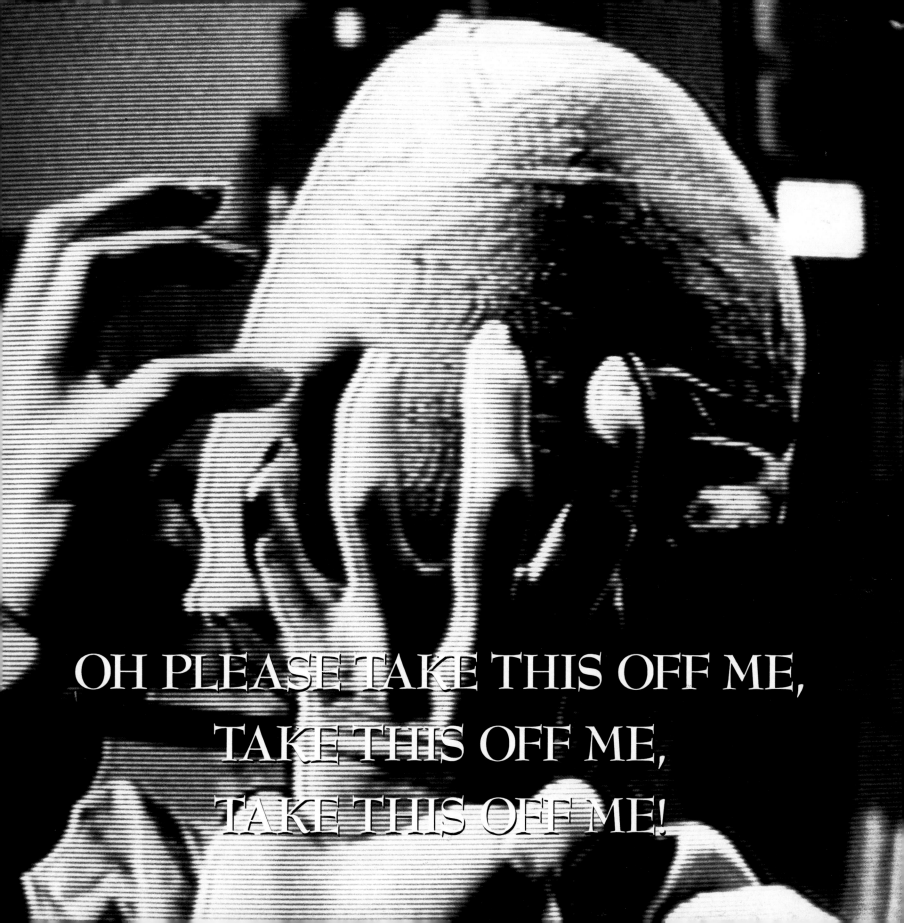

OH PLEASE TAKE THIS OFF ME,
TAKE THIS OFF ME,
TAKE THIS OFF ME!

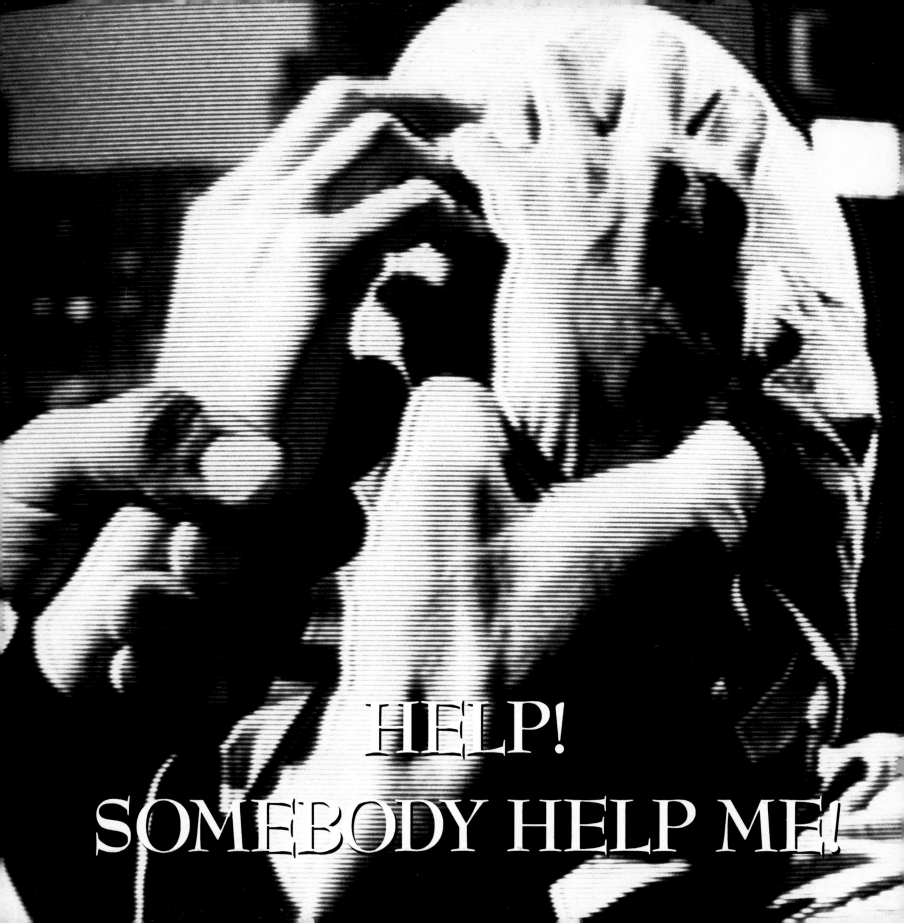

HELP!
SOMEBODY HELP ME!

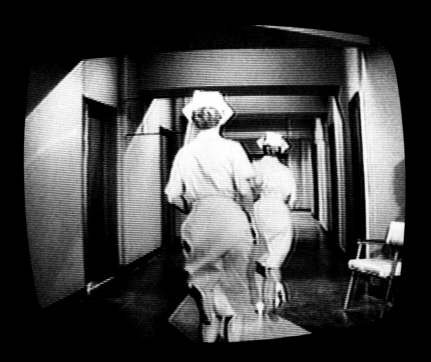

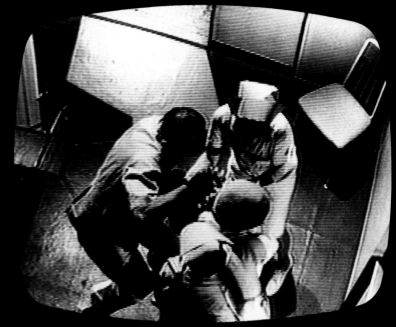

No, no, no, let me go! Let me go!
Please, please let me go, let me go,
oh please, please let me go, let me...

All right then, I will take the bandages off.
Get the anesthetist.

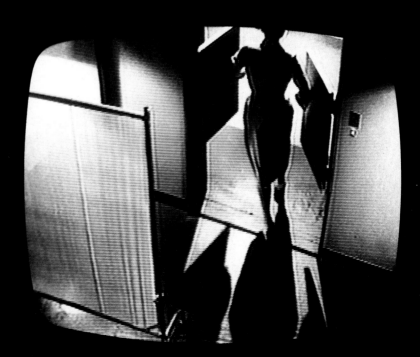

Yes, Doctor.

You look tired, Doctor.

Do I? Well, I hadn't thought about it.
I suppose I am.

You've been under a great deal of tension.
I know how much it means to you,
this case in 307.

Well, you try to be impersonal about these
things. You do everything medically possible,
everything humanly possible, and then,
in the end, you cross your fingers
and you hope for a miracle.
You know, once in a while a miracle
does happen, just often enough to let you
know that you're not wrong—or foolish—
to hope for one.

But you're destroying yourself this way!
Forgive me, but you mustn't let yourself
get personally involved here!

I know—you think I haven't
told myself that?

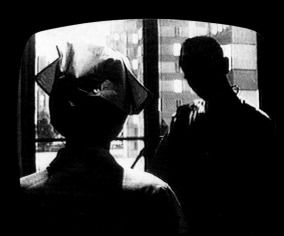

But you see, Nurse,
I've...I've looked underneath
those bandages.

So have I! It's horrible!

No, I mean deeper than that!
Deeper than that pitiful twisted lump
of flesh! Deeper even than that misshapen
skeletal mask. I've seen that woman's
real face, Nurse. The face of a real self.
It's a good face...it's a human face.

I understand. But I must confess—
it's easier for me to think of her as—
as human when her face is covered up.

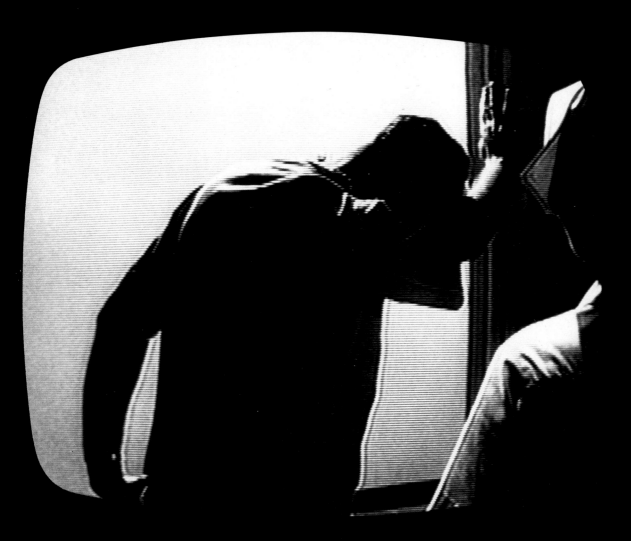

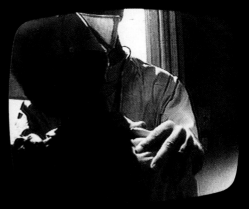

Doctor! Be careful!
What you're talking—

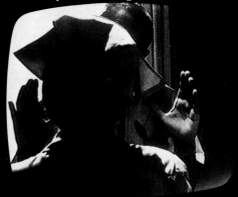

I know—treason!

But why? Why must we feel that way, Nurse?
What is the dimensional difference
between beauty and something repellent?
Is it skin deep? No, less than that!
Why, Nurse? Why shouldn't people
be allowed to be different? Why?

Oh, this case has upset your
balance, your sense of values!

I—I suppose. Don't be concerned,
Nurse. I'll be all right once the
bandages are off. Once I know
one way or the other.

Leader's speaking tonight. He goes on in just a few minutes.

And now, ladies and gentlemen, our Leader.

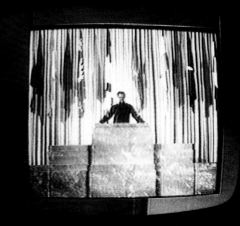

GOOD EVENING, LADIES AND GENTLEMEN.
TONIGHT I SHALL TALK TO YOU
ABOUT GLORIOUS CONFORMITY.
ABOUT THE DELIGHT AND THE ULTIMATE
PLEASURE OF OUR UNIFIED SOCIETY.

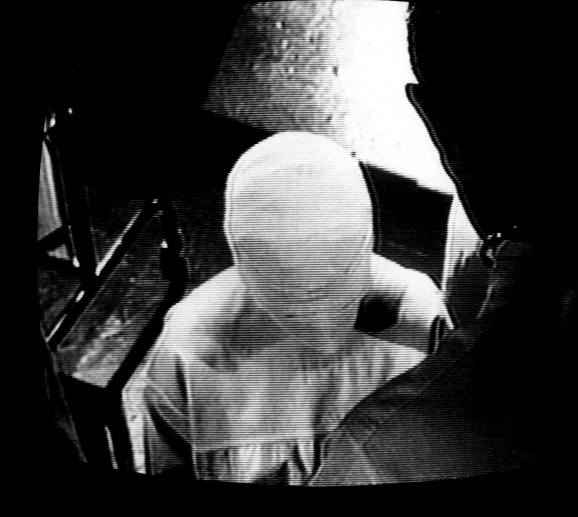

Now I have to ask you once again,
Miss Tyler, and I must insist
that you promise you'll remain rational.
No tantrums. No temperament.
And no violence. You understand?

Now I'll tell you precisely
what I'm going to do. I'm going to cut
the bandages a section at a time.
Then I'm going to unwrap the bandages
very gradually. The process has to be slow
so that your eyes can become
accustomed to the light. As you know,
these injections may have had some
effect on your vision.

I understand.

So, now as I unwrap,
I want you to keep your eyes open,
and I want you to describe to me
the various shadings of light
as you perceive it.

All right.

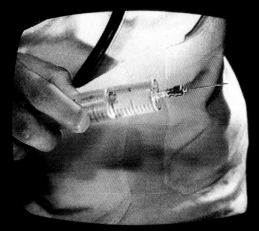

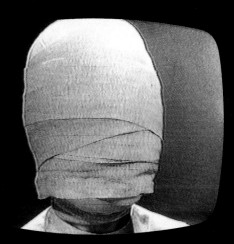

Now if you make any movement
or if you start getting emotional on us,
Miss Tyler, I'm going to have to

...and have the anesthetist put you
under sedation, you understand.

I promise I won't.

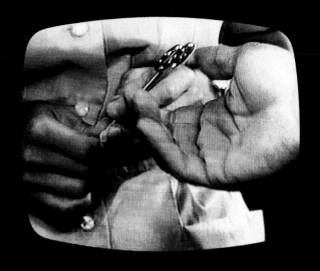

Do you see any light now, Miss Tyler?

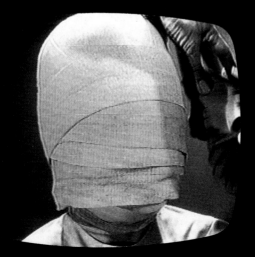

Oh, just a little. It looks gray.

All right now, just be very quiet.

…look up toward the light.

Now, Miss Tyler?

Oh, it's much brighter.

Good, good. Look…

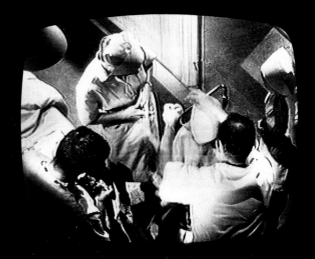

How about now, Miss Tyler?

Oh yes, it's—it's very bright.

Good, now...I'm at the
last layer of bandages, Miss Tyler.

Oh, I can just see you—I can just distinguish
your outline, vaguely, but I can just see you.

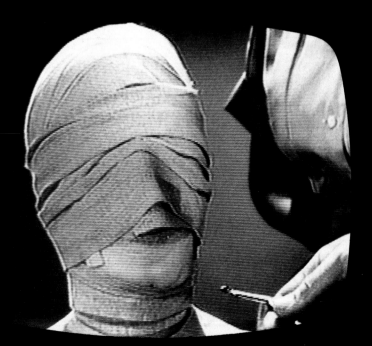

All right,
Miss Tyler, I'm going to remove
the last of the bandages now.
Would you like a mirror?

No. No thank you.
No mirror.

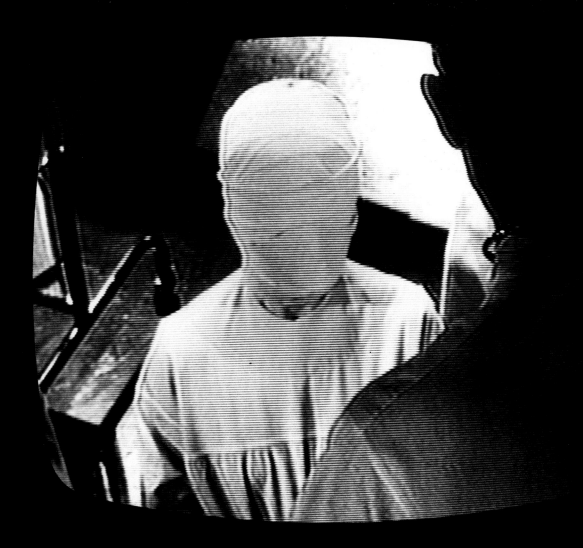

All right then.
I want you to remember this, please.
Miss Tyler? Are you listening?

Yes, I'm listening.

Now we have done all we could do.
If we've been successful,
well and good, there are no problems.
But if, on the other hand,
this final treatment has not achieved
the desired result, please remember,
Miss Tyler, that you can still live
a long and fruitful life
among people of your own kind.
As soon as we discover the results,
we'll either release you, or—

Doctor?

Yes?

If I'm still terribly ugly, well—
is there any other alternative?
Could I please be put away?

Well, under certain circumstances,
Miss Tyler, the State does provide
for the extermination of undesirables;
however, there are many factors
to be considered in the decision.

Under the present circumstances, I—
I doubt very much whether we
would be permitted to do anything
but transfer you to a communal group
of people with your... disability.

You'll make me go then?

That probably will be the case.
Now remain very quiet.
Keep your eyes open.

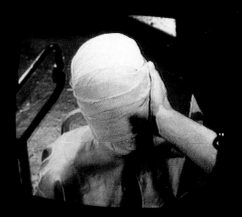

All right, Miss Tyler.
Here comes the last of it.
I wish you every good luck.

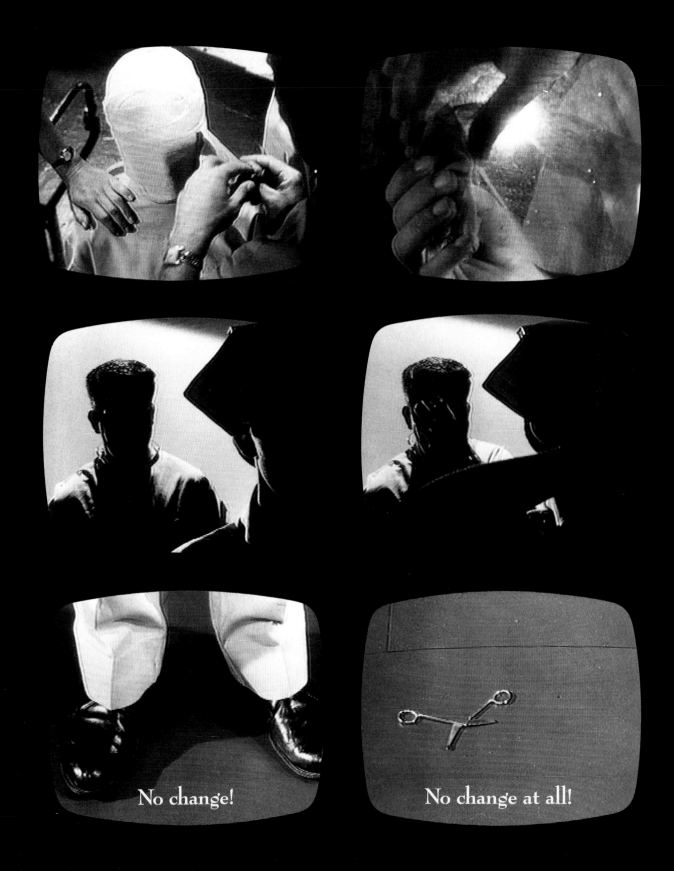

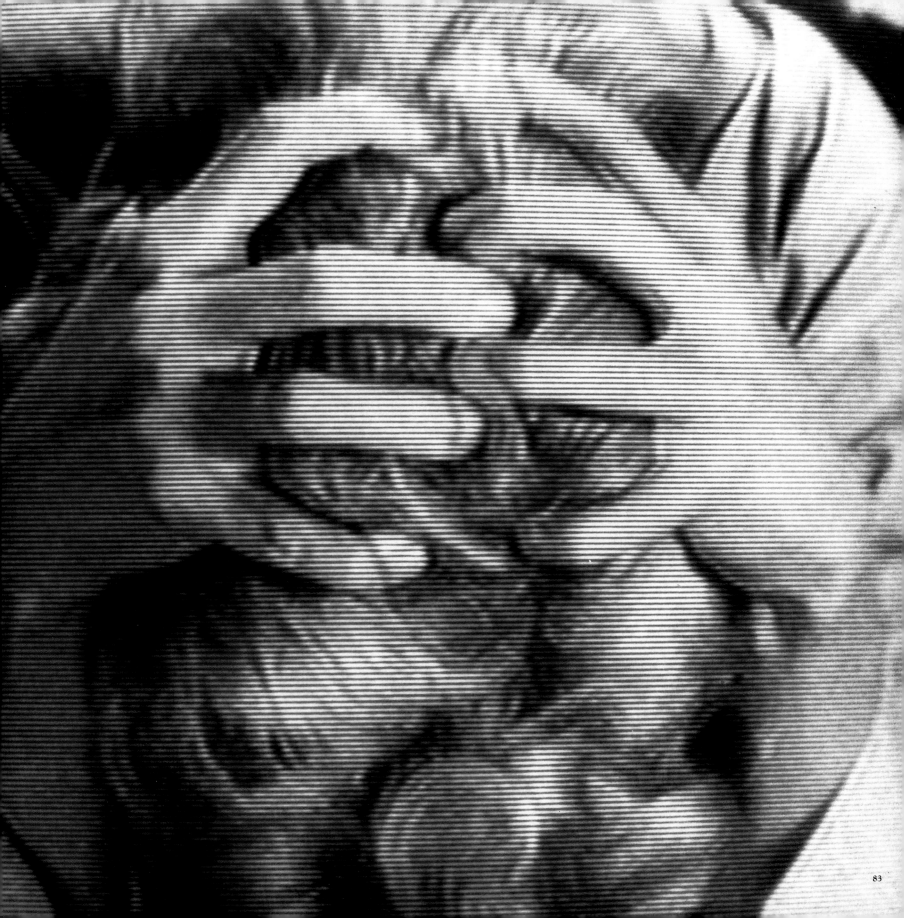

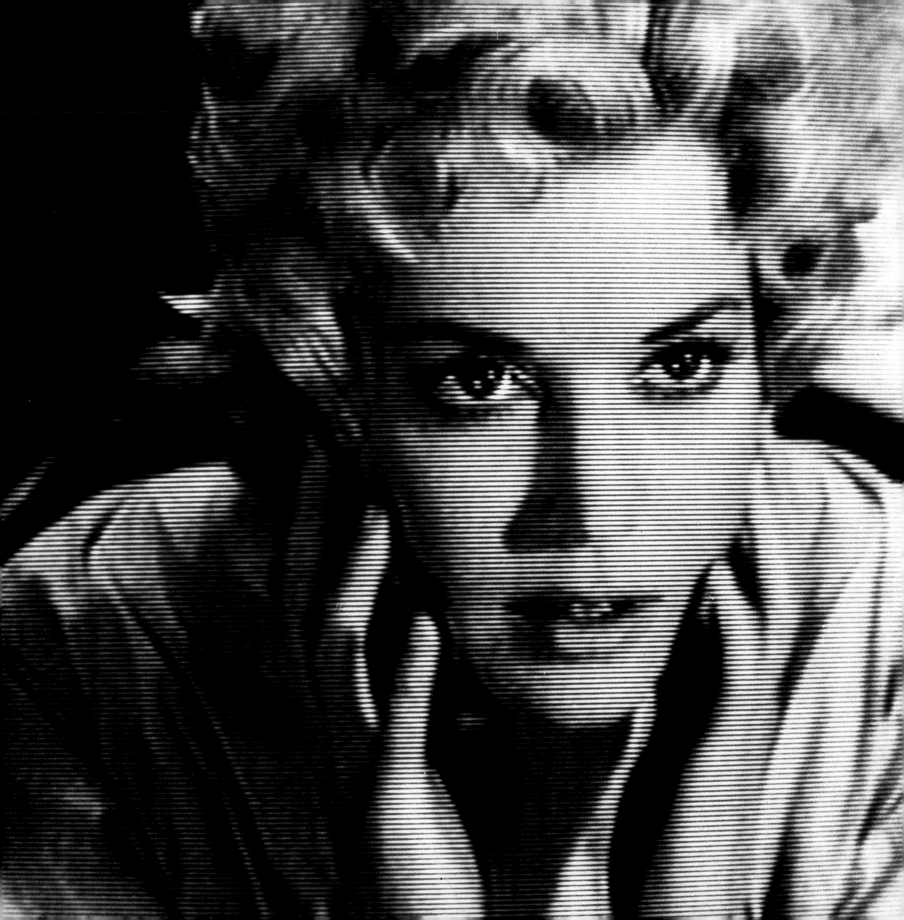

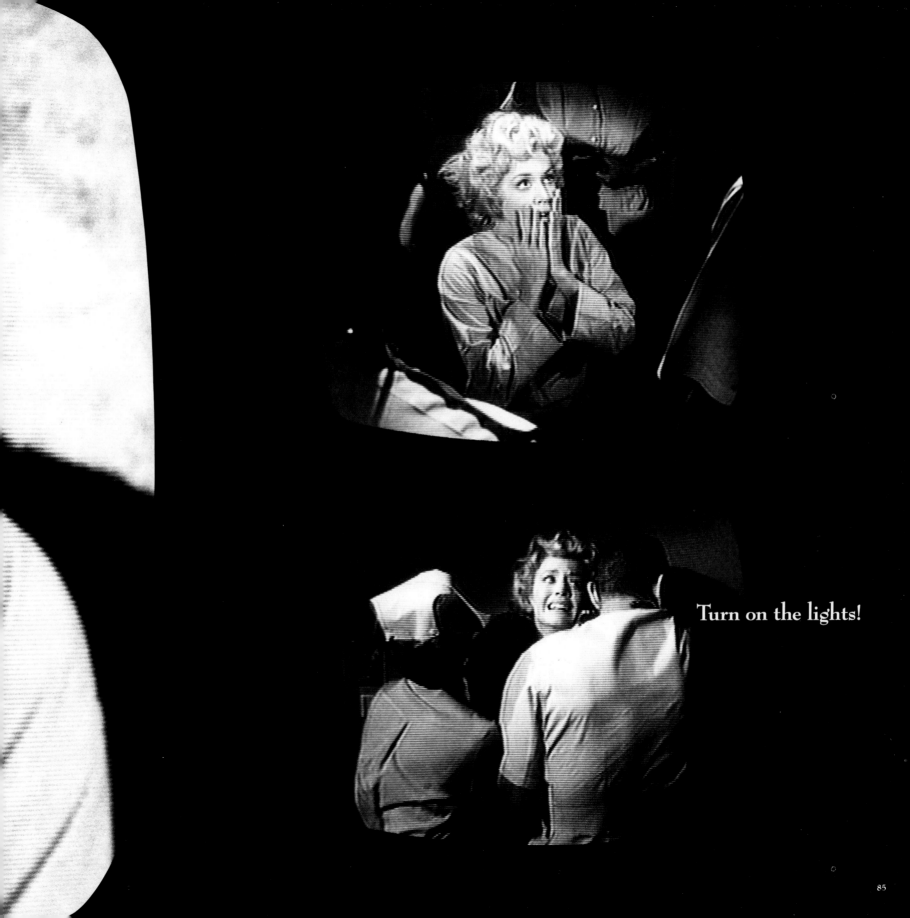

Turn on the lights!

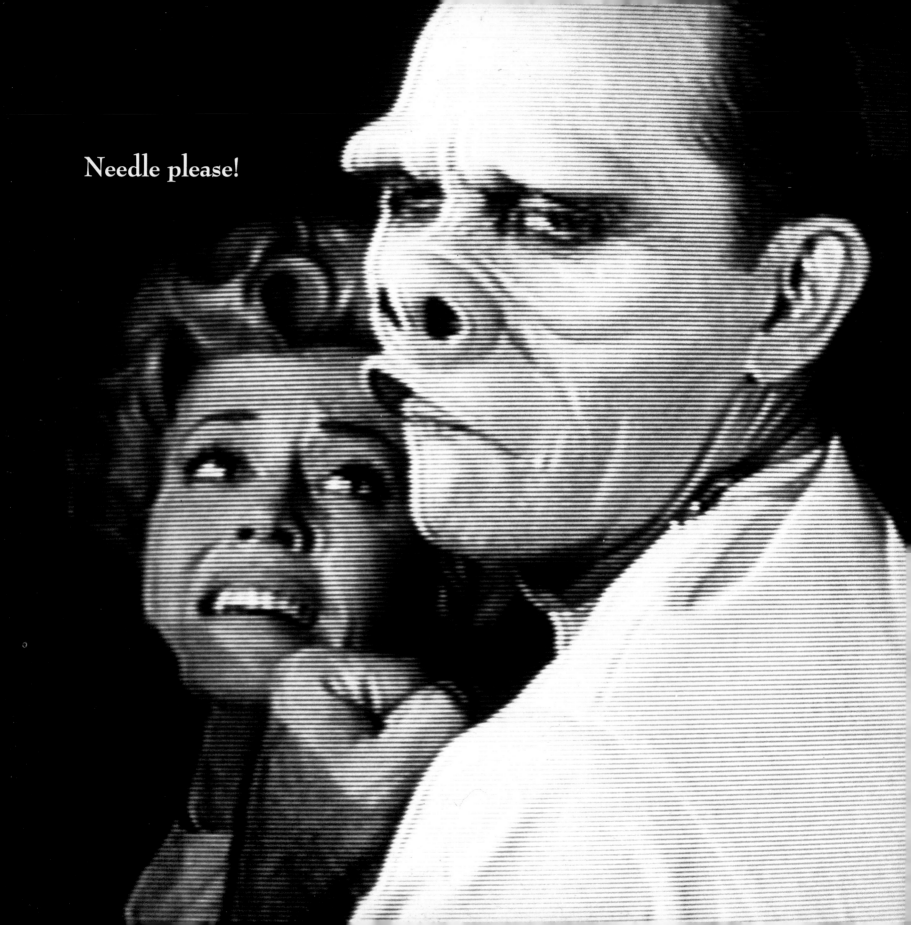

Needle please!

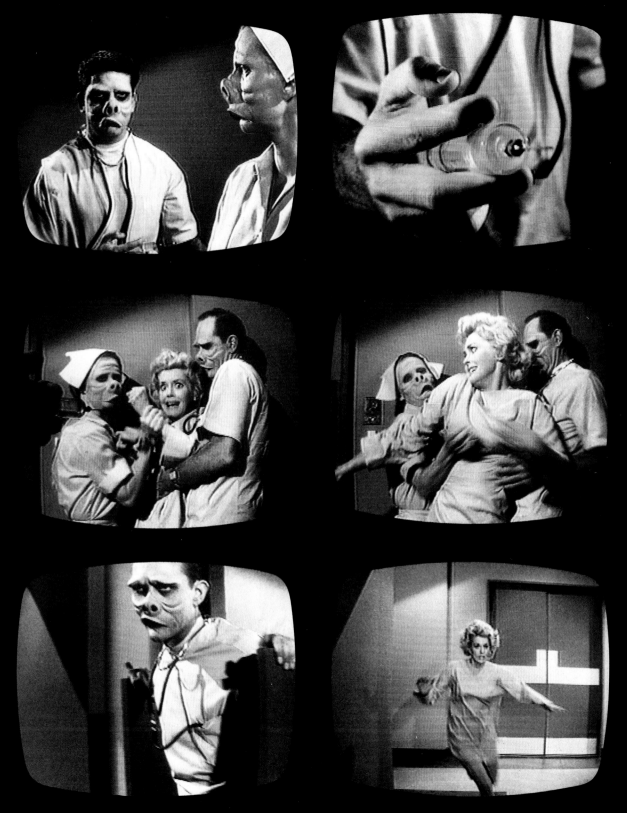

Stop that patient! Stop her!

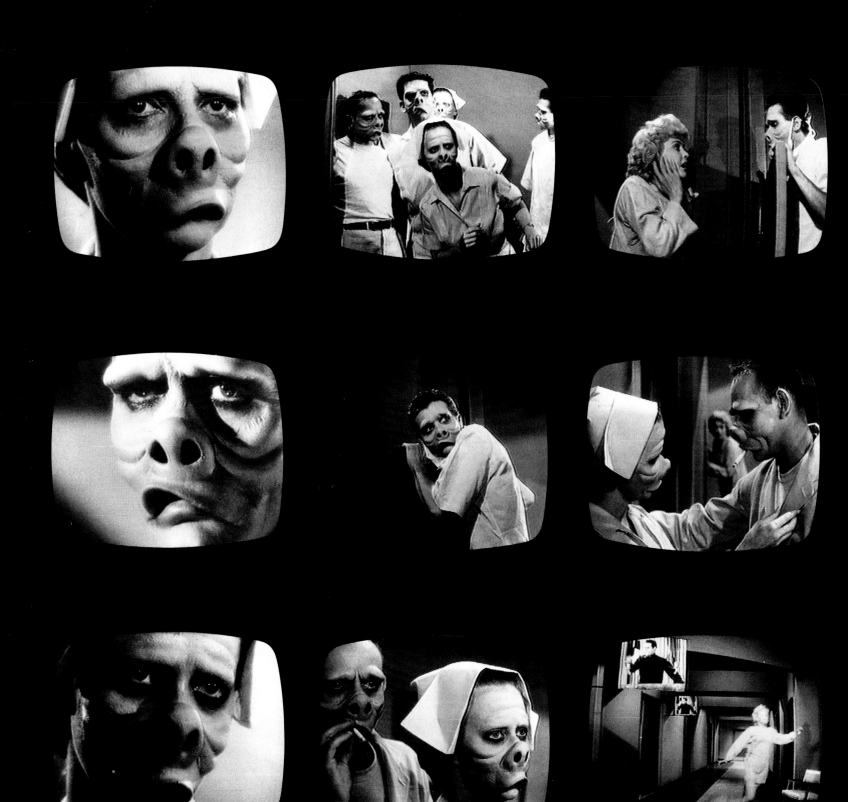

WE KNOW NOW THAT
THERE MUST BE
A SINGLE PURPOSE!
A SINGLE NORM!
A SINGLE APPROACH!
A SINGLE ENTITY
OF PEOPLES!
A SINGLE VIRTUE!
A SINGLE MORALITY!
A SINGLE FRAME
OF REFERENCE!
A SINGLE PHILOSOPHY
OF GOVERNMENT!

WE MUST CUT OUT ALL
THAT IS DIFFERENT LIKE
A CANCEROUS GROWTH!

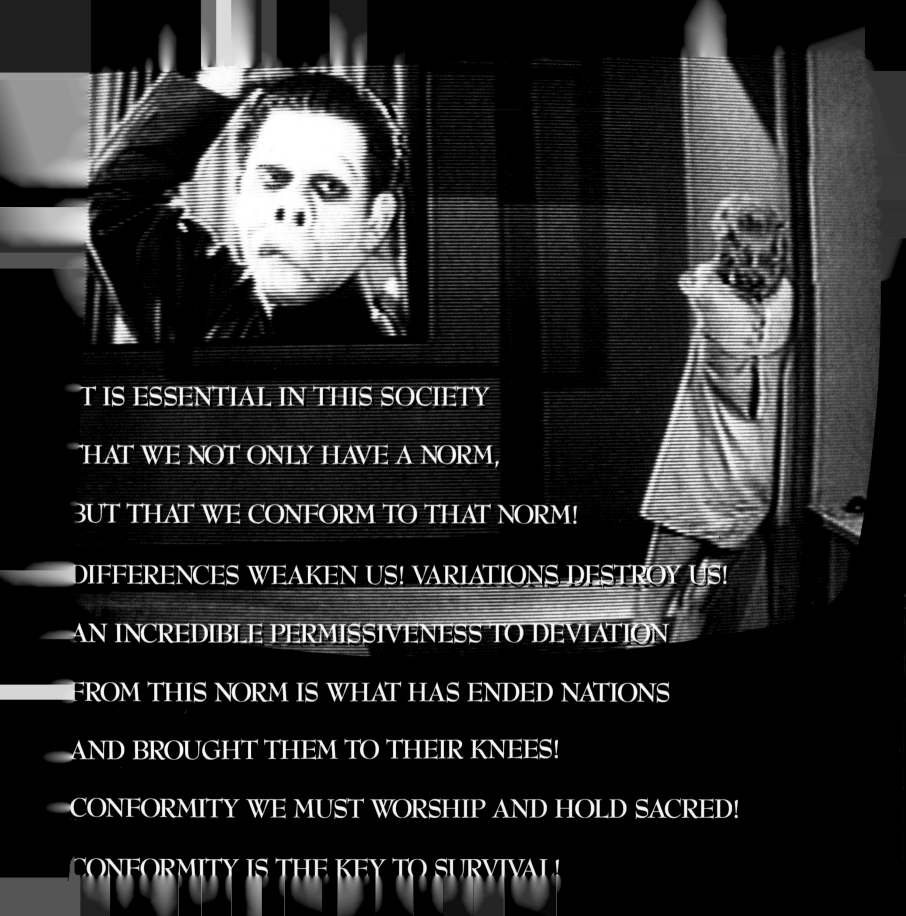

T IS ESSENTIAL IN THIS SOCIETY

THAT WE NOT ONLY HAVE A NORM,

BUT THAT WE CONFORM TO THAT NORM!

DIFFERENCES WEAKEN US! VARIATIONS DESTROY US!

AN INCREDIBLE PERMISSIVENESS TO DEVIATION

FROM THIS NORM IS WHAT HAS ENDED NATIONS

AND BROUGHT THEM TO THEIR KNEES!

CONFORMITY WE MUST WORSHIP AND HOLD SACRED!

CONFORMITY IS THE KEY TO SURVIVAL!

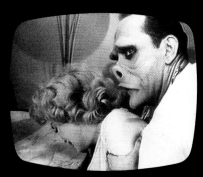

Miss Tyler! Miss Tyler!
Don't be afraid. He's—he's only
a representative from the group
you're going to live with.
Oddly enough, you've come
right to him. Now, come on now,
don't be afraid, he's not going
to hurt you. It's all right.
It's all right, Miss Tyler.

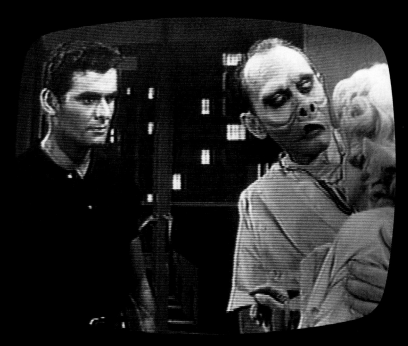 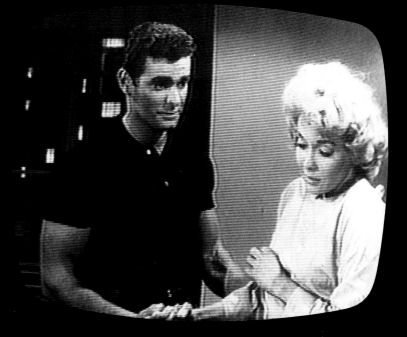

Now this is Mr. Smith. Mr. Walter Smith.
Mr. Smith is in charge of the village group in the north.
He'll take you there tonight. It's the only way now.

Miss Tyler? We have a lovely village and wonderful people.
I think you're going to like it where I'm going to take you.
You'll … uh … you'll be with your own kind.
And in a little while—oh, you'll be amazed how little a while—
you'll feel a sense of great belonging. You'll feel a sense
of being loved. And you will be loved, Miss Tyler.

Miss Tyler? Would you get your
things now? We can leave any time.

Mr. Smith?

Yes?

Why do we have to look like this?

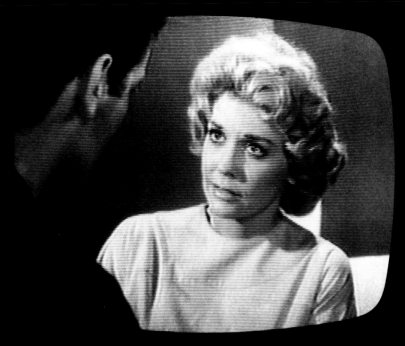

I don't know, Miss Tyler.
I really don't know.
But you know something? It doesn't matter.
There's an old saying ... a very, very old saying:
Beauty is in the eye of the beholder.
When we leave here ...
when we go to the village ...
try to think of that, Miss Tyler.
Say it over and over to yourself:
Beauty is in the eye of the beholder.

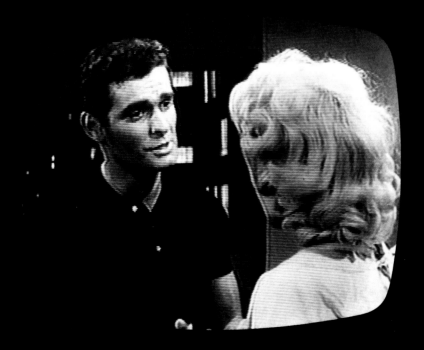

Come on now. We'll get your things and we'll leave.

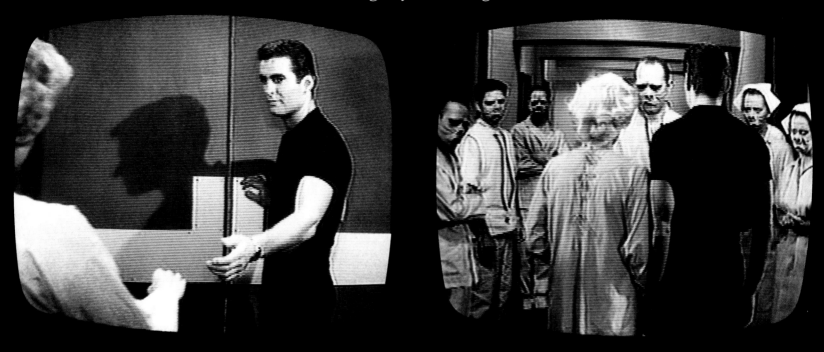

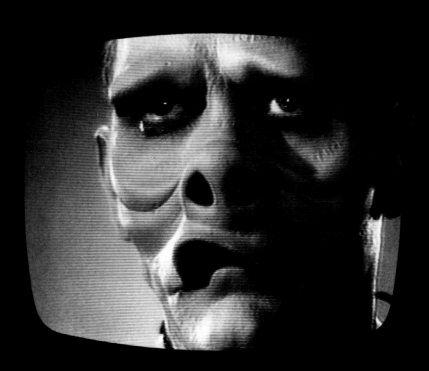

Goodbye, Miss Tyler.

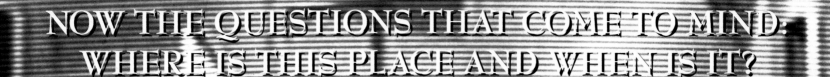

NOW THE QUESTIONS THAT COME TO MIND:
WHERE IS THIS PLACE AND WHEN IS IT?

WHAT KIND OF WORLD,
WHERE UGLINESS IS THE NORM
AND BEAUTY THE DEVIATION FROM THAT NORM?

# YOU WANT AN ANSWER? THE ANSWER IS...

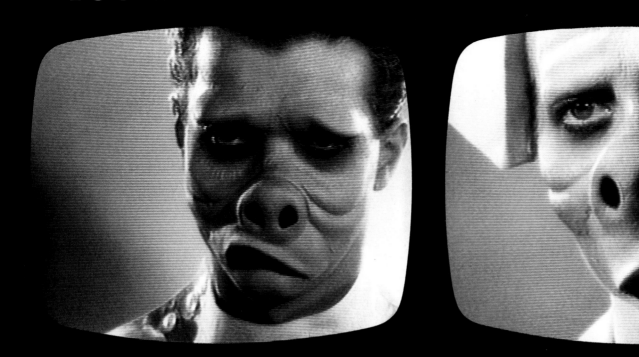

# ...IT DOESN'T MAKE ANY DIFFERENCE.

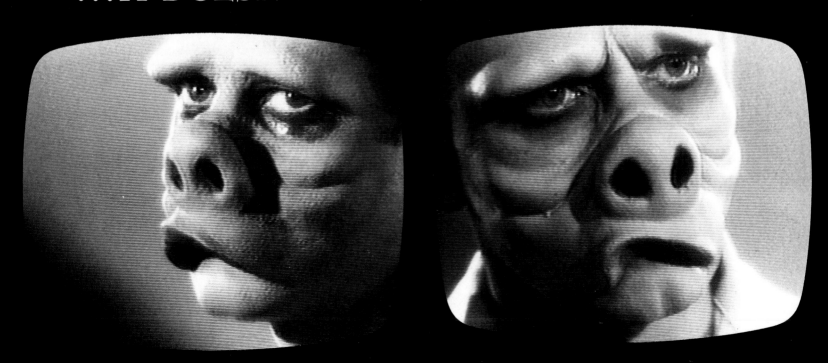

# BECAUSE THE OLD SAYING HAPPENS TO BE TRUE...

BEAUTY IS IN THE

IN THIS YEAR OR A

ON THIS PLANET OR

HUMAN LIFE PERHAPS

BEAUTY IS IN THE

LESSON TO BE LEARNED

EYE OF THE BEHOLDER

HUNDRED YEARS HENCE

WHEREVER THERE IS

OUT AMONGST THE STARS

EYE OF THE BEHOLDER

IN THE TWILIGHT ZONE

# THE TWILIGHT ZONE

...is a world that allows for things to happen that do not happen in real life: fantasies operate, wishes are fulfilled, life's loose ends are tied up, frustrations are resolved, discontents are played out, dreams come true, magic asked for is delivered. Unbridled imagination, working to the benefit—or destruction—of commonplace people.

The challenge, for the writer, of creating a true *Twilight Zone* story is to stretch, bend, and otherwise distort reality so as to tantalize the viewer, but never so far that it can't snap back into focus at the last minute to provide a recognizable and satisfying irony or insight. Therefore, the writer walks a fine line, mixing reality and unreality without falling into an attempt merely to shock, or to propose outrageous situations that finally have nothing to say to us.

This is not to say that a writer undertaking to make up a *Twilight Zone* story has to first find some deep-dish, meaningful message and then construct a story that will convey it. More likely, a writer will take a "What if....?" that has always fascinated him and, in the course of playing it out, will find a conclusion that provides the satisfying or disturbing capper. The writer is free to pose almost any "What if...?" and proceed with it to some conclusion unfettered by the need to mirror real life; but he can never treat far-outness as an end in itself—the conclusion reached must ultimately appeal to our sense of truth, justice, or irony. It must have a crackling resonance in common human experience.

—From the personal notes of

# BUCK HOUGHTON
## PRODUCER (1959–1962)

# E A R T H

It's a race of men struggling for survival

It isn't a place of all beauty

We may yet have wars

And there still remains prejudice

And as long as men walk

There will be angry men

Jealous men

Unforgiving men

But it has one thing:

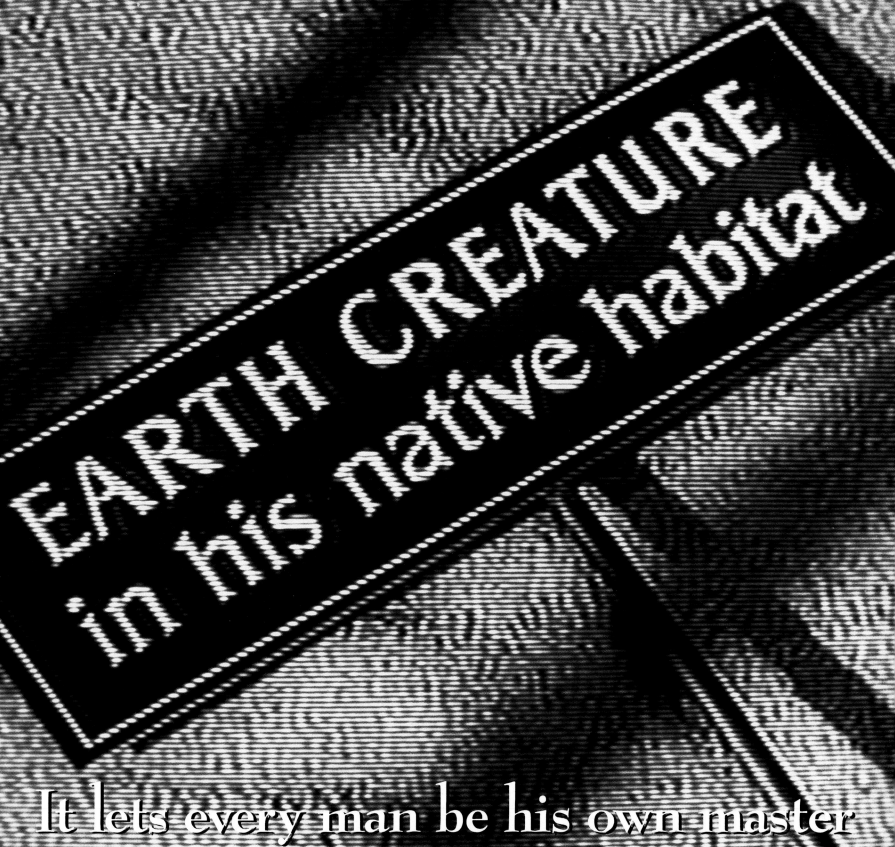

It lets every man be his own master

# SOME PEOPLE AREN'T BUILT FOR COMPETITION

Or big pretentious houses they can't afford

Or rich communities they don't feel comfortable in

Or country clubs they wear around their neck

    like a badge of status

*He's been cannonaded by all the enemies of his life*
*His insecurity has shelled him*
*His sensitivity has straddled him with humiliation*
*His deep-rooted disquiet about his own worth*
*Has zeroed in on him*
*Landed on target and blown him apart*

Handsome, prosperous, the picture of success

The man who has achieved every man's ambition

Beautiful children, beautiful home, beautiful wife

# IDYLLIC?

# IF YOU'RE A SUCCESS
# YOU'RE BOUND TO THINK IT'S A DREAM
# IF NOT YOU THINK IT'S A NIGHTMARE

*Sometimes*
*I'd like to escape*
*Away from this turmoil*
*To some simpler existence*

# I

HAD BEEN LIVING

IN A DEAD RUN

AND ONE DAY
I KNEW I HAD TO
COME BACK HERE

I HAD TO
COME BACK
AND GET ON A
MERRY-GO-ROUND
AND EAT
COTTON CANDY
AND LISTEN TO
BAND CONCERTS

I

HAD TO STOP AND
BREATHE AND
CLOSE MY EYES
AND SMELL
AND LISTEN

BEAUTIFUL
THESE SORT OF
PLACES WHERE
THERE ARE NO
BOOKS TO KEEP
WHERE I'M NOT
A LITTLE MAN
WITH NO FUTURE
AND NO PAST

# WE ARE ALL

# TRAVELERS

*That's the signpost up ahead...*

The trip starts in a place called birth

HOTEL
REAL

Room for one more . . .

d ends in that lonely town called death

TIM
ANI
METHOI
OF
EXECUTION
UNKNOWN

THIS IS THE COMEUPPAN

WHEN THE LEDGER OF HIS LI

CE AWAITING EVERY MAN

FE IS OPENED AND EXAMINED

WHY DOES A M

AN HAVE TO DIE?

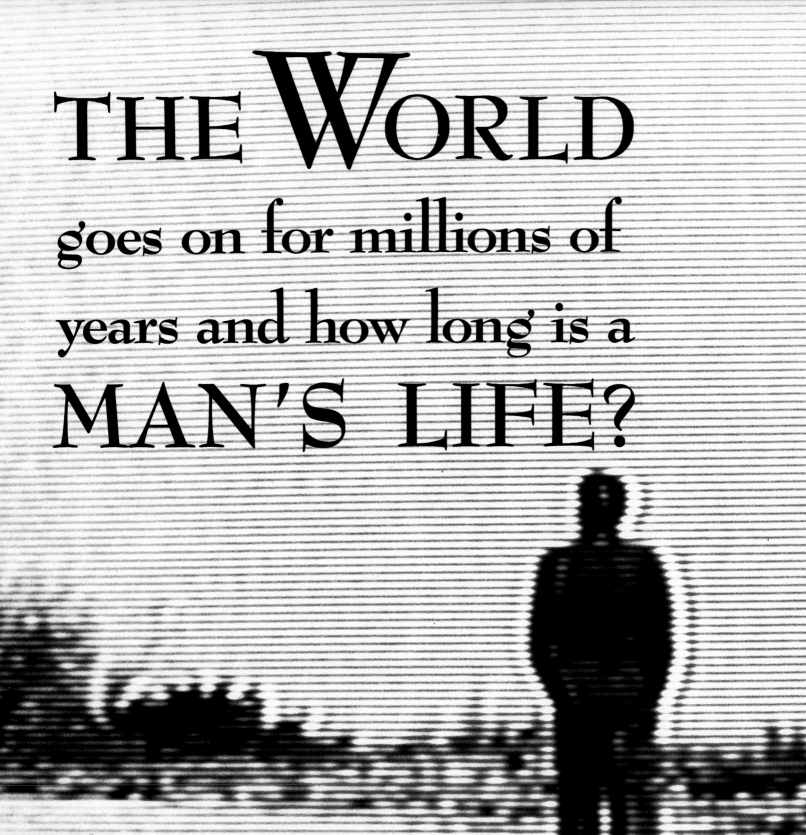

A handful of years and then
an eternity down under the ground!

W hy does he have to die
almost the moment he's been born?

O nly if a man lived forever
could there be any point to living at all!

No man can prolong
His allotted hours
He can only live them
To the fullest

# CLOCKS ARE MADE BY MEN

# GOD

# CREATES

# TIME

# And perhaps
Across his mind there'll flit
A little errant wish
That a man might not have to
Become old
And he'll smile then, too
Because he'll know
It is just an errant wish
Some wisp of memory
Not too important, really...

Each man
Measures
His time
Some with hope
Some with joy
Some with fear

At night, every night, I dreamed of immortality
I thought if a man lived forever, he'd grow wiser
But that isn't true; you just go on living

...some laughing ghosts

that cross a man's mind

# An observation as to the psychological nature of man:

*He's a frightened breed*

Being frightened is a normal, natural human function

It's how you *react* to fright

That's what *really* counts

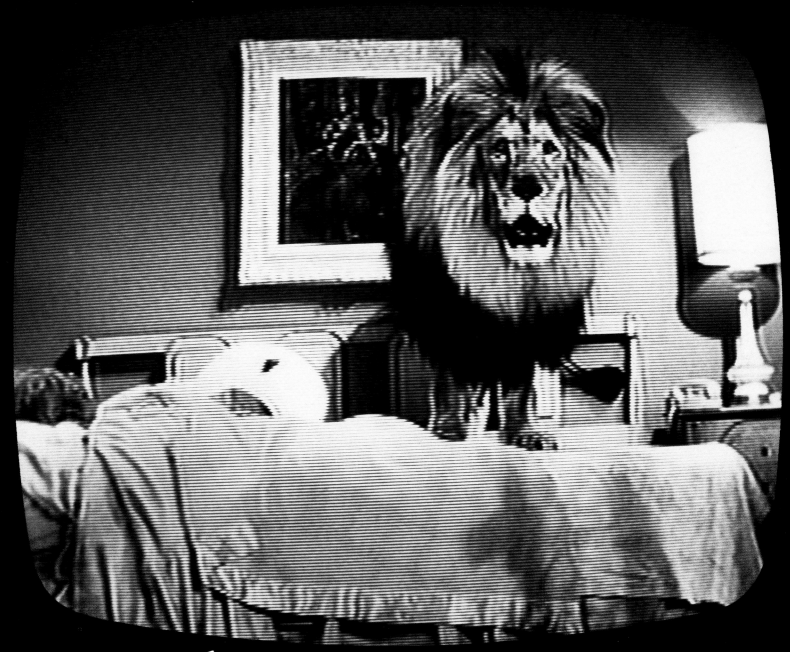

I don't want any of
the outside world coming in

IT DOESN'T HAVE TO EXIST

IF I SHUT MY EYES

IF I SHUT MY EYES

IT ALL DISAPPEARS

IF I WISH HARD ENOUGH

I CAN WISH IT ALL AWAY

How thin a line separates that which we assume to be real with that manufactured inside of a mind?

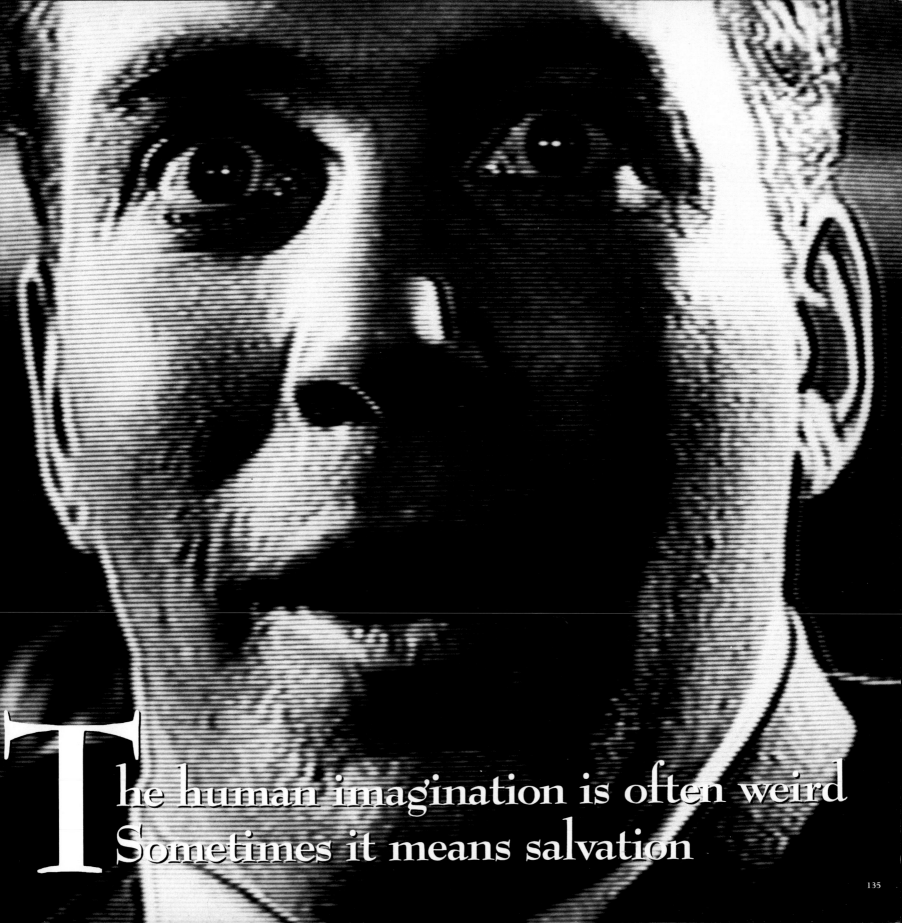

The human imagination is often weird
Sometimes it means salvation

The fear
has left me
Now I'm numb
I have
no feeling
It's as if
someone had
pulled out
some kind of
plug in me
and everything:
Emotion
Feeling
Fear
has drained out
And now
I'm a cold
shell

I'm
conscious
of
things
around
me
now
The
vast
night
The
stars
that
look
down
from
the
darkness

I shot an arrow into the air;
It landed I know not where.

—*Nursery rhyme for the Age of Space*

UP THERE

In the vastness of space

In the void that is sky

UP THERE

Is an enemy known as

ISOLATION

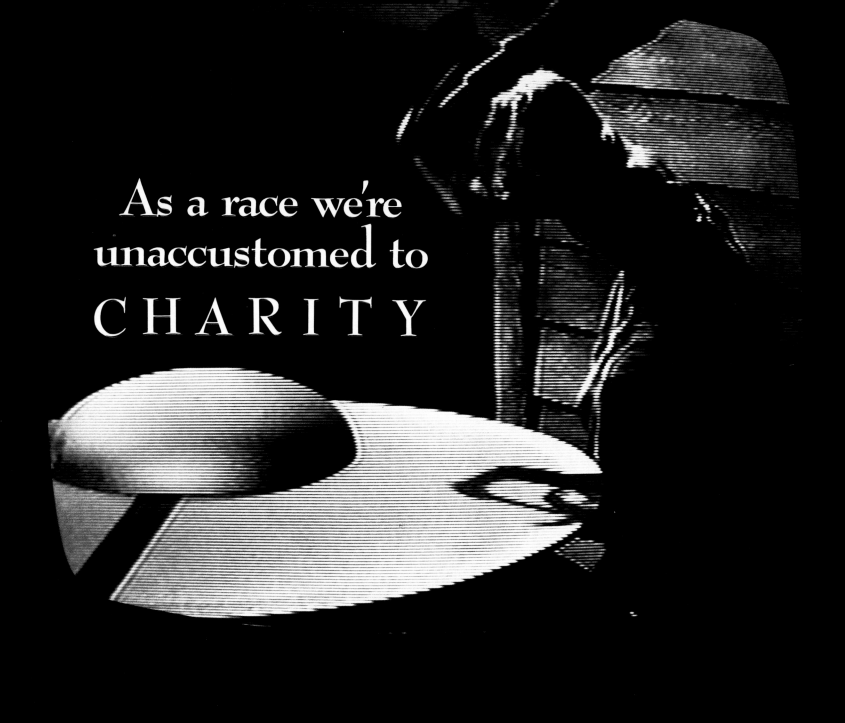

# BRUTALITY
is a far more universal language to us than an expression of friendship from outer space

PEOPLE ARE AFRAID BECAUSE THEY SUB

EVERY FINE IDEA

EVERY MARVELOUS INVEN

THEY SUBV

THEY MAKE IT

THEN TOO LATE, FAR TOO LATE THEY ASK

BY THEN IT'S

VERT EVERY GREAT THING EVER DISCOVERED

EVER THOUGHT

TION EVER CONCEIVED

ERT IT

CROOKED AND DEVIOUS

THEMSELVES THE QUESTION WHY

TOO LATE

IS TOO LATE

# I REMEMBER

I remember it as a place of color

I remember that in the autumn the leaves changed

Turned different colors

Red, orange, gold

I remember streams of water that flowed down hillsides

And the water was sparkling and clear

I remember clouds in the sky

White billowy things

Floated like ships, like sails

# THE EARTH

And I remember night skies like endless black velvet

Night was a quiet time when the earth went to sleep

Kind of like a cover that it pulled over itself

It was a darkness that felt like a cool hand just brushed back tired eyes

And there was snow on the winter nights, gossamer stuff

Floated down and covered the earth

Made it all white and cool

And it was good then

It was right

AMERICA'S
TWILIGHT ZONE

BY J. HOBERMAN

# In America, television *is* history. *The Twilight Zone* doesn't only belong to a brief but distinctive epoch in our recent past—it could almost provide that period with a name.

*The Twilight Zone*, which premiered on CBS in the fall of 1959, and, with one delayed season, ran through the spring of 1964, defined the shadowy transition between the Fabulous Fifties and the Psychedelic Sixties. The show's span encompassed the birth of the Space Race, the flowering of the Civil Rights Movement, and the life and death of the New Frontier. This era was not only the Acme of the American Empire, but also the Age of Strontium 90, the Day of *The Jetsons*, the Moment of the Missile Gap. It was a time whose most sophisticated pop forms were Cool Jazz and Sick Comedy, and whose quintessential architectural structures were the Berlin Wall and the suburban fallout shelter—a household necessity sometimes sold as the "Family Room of Tomorrow." As the aspirin-ad angst music, op art patterns, and beatnik bongos of the series' celebrated credit sequence suggest, this historical twilight zone was a time of affluence and anxiety, of suave hysteria with a continual backbeat of crisis.

*And people walked and drove and bought and sold*
*And fretted and laughed*
*The world went on much as it had been going on*
*With a tentative tiptoeing alongside a precipice of crisis*
*Myriad problems, major and minor*
*That somehow had lost their incisive edge of horror*
*Because we were so familiar with them*

"To Serve Man" (3/2/62)

**R**od Serling, the son of a Binghamton, New York, butcher, and an amateur boxer and World War II paratrooper who attended Antioch University on the GI Bill, broke into radio in the late 1940s, then crossed over to television. *Patterns*—his caustic account of a corporate power struggle—was a critical sensation on *Kraft Television Theatre* in early 1955 and so popular that it was performed live again the following month.

Serling was not a man to shy away from serious themes. In addition to meditating on death and failure in his most celebrated teledrama (and second Emmy winner), *Requiem for a Heavyweight*, first telecast on *Playhouse 90* in October 1956, he addressed the Cold War and the Hungarian Revolution, and wrote of POWs and anti-Semitic murderers, while battling the often ridiculous network censorship that remained the legacy of the medium's Cold War origins. After the mangled 1957 telecast of his Capitol Hill drama, *The Arena*, Serling maintained that he would have had a more "adult" play if he had transposed the setting one hundred years into the future and peopled the Senate with robots. Clearly, the writer was poised at the threshold of that fifth dimension where Martians could stand in for oppressed minorities or repressed fears.

*The Twilight Zone* would be the arena for Serling's distinctive brand of paranoid liberalism, the place for the imaginative recasting of topical anxieties into twenty-three-minute metaphors. "The place is here, the time is now, and the journey into the shadows that we are about to watch could be our journey," he intoned by way of an introduction.

Serling's new series was itself a twilight zone in which the live drama of TV's Golden Age was revamped to fit the new economic imperatives of the half-hour telefilm. To protect his serious themes and ambitious characterizations, Serling adopted the didactic rhythms and blunt characterizations of the sitcom, usually building up to a dramatic frisson. Serling, who along with Paddy Chayefsky, Gore Vidal, and Reginald Rose had been among the reigning middlebrows of the Golden Age, had swerved from the prestigious to the declassé, a maneuver that he feared might seem a sellout. On the eve of *The Twilight Zone*'s premiere, Serling told the *New York Times* that the reason he wasn't "writing any material that lies in the danger zone" was purely tactical: "I am not a meek conformist but a tired nonconformist."

ROD SERLING, one of television's
most famous playwrights, brings you
an extraordinary dramatic series

# TWILIGHT ZONE

defined by the author as:
"The land that lies between science
and superstition, between the
pit of man's fears and the summit
of his knowledge. You will find
the bizarre, but the believable;
the different, the shocking that
is yet understandable. Its tales
must be shown; they cannot
be told. And each carries with it
its own special surprise."

In tonight's drama—
A small-town main street lies
deserted at midday...and a
frightened man asks,
"WHERE IS EVERYBODY?"

Virtually every *Twilight Zone* theme is implicit in the premiere episode, "Where Is Everybody?" (10/2/59). This terse tale of a uniformed amnesiac who finding himself totally alone in a mysteriously abandoned town—but feeling somehow under observation—manages to conflate loss of identity with the end of the world, suggesting the transformation of ordinary reality into an overdetermined realm of inauthentic experience. For the next five years *The Twilight Zone*'s key recurring image would be that of the empty place, the department store after hours, the deserted city, the barren asteroid.

The imagery of space probes and extraterrestrial invasion were *Twilight Zone* commonplaces, but the strange planet was often earth or the alien was us, as in "I Shot an Arrow into the Air" (1/15/60) or "The Invaders" (1/27/61). The series' most reliable law was that a close encounter with

an alien civilization would only undermine our anthropocentric universe. A human being who entered *The Twilight Zone* was apt to wind up as the prize exhibit in some extraterrestrial zoo—as in the ironically titled "People Are Alike All Over"

"The Invaders"

(3/25/60). The alien tome that provided the title for "To Serve Man" (3/2/62) turned out to be a human cook-

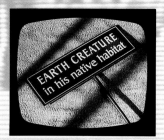

"People Are Alike All Over"

book. "The Monsters Are Due on Maple Street" (3/4/60) has otherworldly Joe McCarthys manipulating the denizens of an idyllic small-town neighborhood—actually MGM's old Andy Hardy set—so that they turn against each other in a murderous frenzy, just as the aliens had hoped. "The Shelter" (9/29/61) uses the threat of nuclear war to produce the same effect. Here, as in other episodes, the black-and-white mind-set of the Cold War was subverted by the disconcerting notion that truth might be a subjective matter. "Beauty is in the eye of the beholder," Serling muses at the end of perhaps the series' finest episode. "Lesson to be learned . . . in *The Twilight Zone*."

As socially conscious pulp, *The Twilight Zone* was not without precedents. Such sci-fi philosophers as Arthur C. Clarke, Philip K. Dick, Robert Heinlein, and—above all—Ray Bradbury were honored forefathers. The often sentimental Serling was fortunate to have input from the more visceral Richard Matheson and Charles Beaumont. *The Twilight Zone* also shows the influence of the notorious E.C. Comics, which flourished during the Cold War and had been banned since 1954. Serling appropriated and modulated the E.C. formula that put brutal irony in the service of blatant moralizing. Although he tended to eschew lurid shock effects—let alone the E.C. horror-style

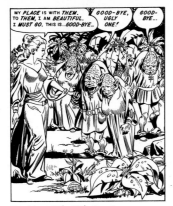

Panel from "The Ugly One,"
*Weird Science #21*, Sept.–Oct. 1953

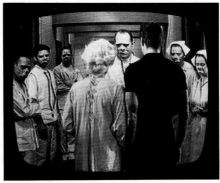

"The Eye of the Beholder"

gross-out—Serling shared E.C.'s contempt for so-called normality, as well as their outspoken hostility toward neo-Nazis and the Ku Klux Klan.

In *The Twilight Zone*, political allegories abound. "The Eye of the Beholder" (11/11/60) is only one of several crypto–civil rights tales. "Judgment Night" (12/4/59) and "Death's-head Revisited" (11/10/61) are typical of the recurring anti-Nazi shows. "He's Alive" (1/24/63) features a ranting Dennis Hopper as an American führer, "The Mirror" (10/20/61) has Peter Falk playing a no less boisterous Castro manqué, and a Nikita Khrushchev look-alike even shows up at the end of "The Whole Truth" (1/20/61) to be bamboozled in the name of truth and freedom by Jack Carson's fast-talking huckster. The quintessential *Twilight Zone* attack on totalitarianism, however, is "The Ob-solete Man" (6/2/61), in which a fas-cistic superstate condemns librarian

*Any state, any entity, any ideology that fails to recognize*

*The worth, the dignity, the rights of man*

*That state is obsolete*

"The Obsolete Man"

Burgess Meredith to death for his retrograde life-style. Albeit heavy-handed, the show is redeemed by its expres-sionistic sets and ritual chanting of the mantra *ob-so-lete*.

The final season's "Number Twelve Looks Just Like You" (1/24/64), set in a future society where everyone is sur-gically altered to resemble fashion models, is the most insistent of anticonformist diatribes. If the teenage heroine's doomed rebellion against "the transformation" seems unnecessarily strident, the viewer is still brought up short by the original midprogram commercial for "new mild Thrill dish detergent"—a gently waving forest of arms accom-panied by the crooning suggestion "How would you like to buy a new pair of hands?" In the context of such shameless advertising ploys, in which doing a sink full of dirty dishes becomes the occasion for entering some Brave New World, Serling begins to seem like a living-room Bertolt Brecht.

"Number Twelve Looks Just Like You"

Although Serling functioned as narrator, his tight-lipped, emphatic delivery punching across the flourishes of his baroque prose style ("Consider, if you will . . ."), he didn't appear as a playfully ubiquitous master of ceremonies until the series' second season. Then, as tense as the theme music, the chain-smoking writer emerged as a stellar pop intellectual, the epitome of mature, narrow-lapeled cool. Serling was the anthology's single constant, the first TV-generated auteur-star since Jack Webb premiered *Dragnet* in 1952.[1]

[1] Webb doubtless loathed *The Twilight Zone's* liberal politics, but he paid homage to Serling with his infamous *Red Nightmare*. This dreamlike evocation of a Communist coup in an idyllic sitcom town, made with Jack Warner for the Defense Department in 1965, is a virtual mirror image of the *Twilight Zone* format.

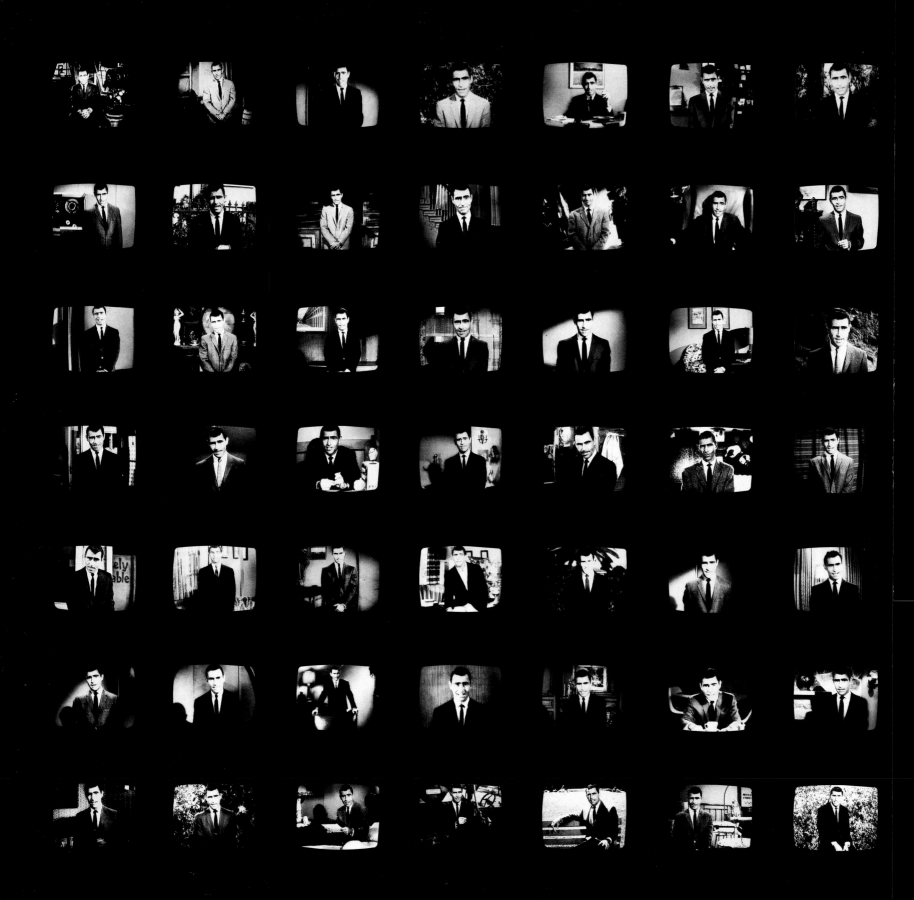

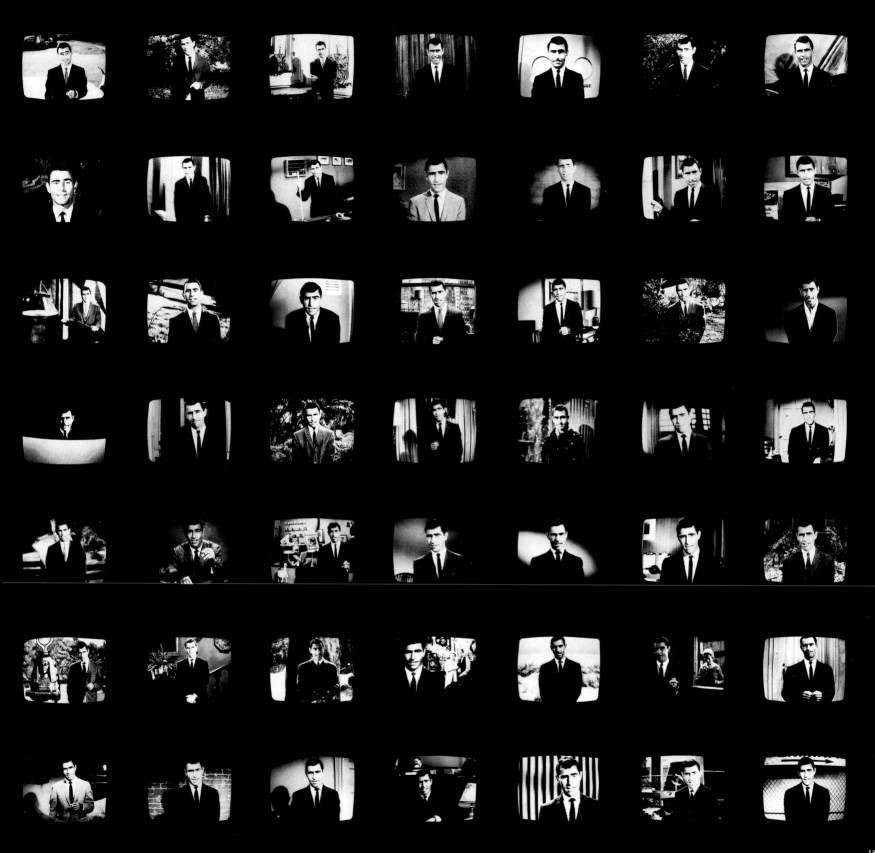

As an icon, Serling belonged to an urbane glamour group whose other members might include JFK, Sean Connery's 007, the ring-a-ding Frank Sinatra, the buttoned-down Bob Newhart, and Hugh Hefner. But his real-world equivalent was the host of an equally prestigious and even longer-running half-hour series, Walter Cronkite. While Cronkite's *The Twentieth Century* (CBS, 1957–69) took the lead in educating the public to the horrors of recent history, particularly in World War II, *The Twilight Zone* was in the TV vanguard in visualizing the potential horror of World War III.

Burgess Meredith in "Time Enough at Last"

In "Time Enough at Last" (11/20/59), Burgess Meredith gives an amusing performance as a grotesquely nearsighted bookworm who miraculously survives World War III long enough to go traipsing through the radioactive rubble before one of the cruelest of *Twilight Zone* twists delivers the character's personal catastrophe. Less than two months later, "Third from the Sun" (1/8/60) presaged the sense of impending annihilation that would grip the nation during the Cuban Missile Crisis in the autumn of 1962.

*Everyone I've talked to lately*
*They've been noticing it*
*That something's wrong*
*That something's in the air*
*That something's going to happen*
*And everybody's afraid*

"Third from the Sun"

"Probe 7—Over and Out"

Whether explicitly nuclear or otherwise, the apocalypse was never far away. "The Midnight Sun" (11/17/61) was telecast on the day the U.S. consolidated its drive for "push-button warfare" with the first successful launching of a Minuteman missile from an underground silo. The episode substitutes a kink in the earth's orbit—an analogue to what we currently call "the greenhouse effect"—for an atomic holocaust. Instead of blowing up, the planet is falling into the sun. Rape and pillage seem imminent, and even the pigment is boiling on the heroine-artist's canvases as the radio weatherman goes nuts on the air. "Even at midnight, it's high noon—the hottest day in history," Serling solemnly explains. "Two" (9/15/61) and "Probe 7—Over and Out" (11/29/63) both mythologize Armageddon by making Adam and Eve the last, as well as the first, couple on earth.

The truth was that *Twilight Zone* fantasy was one of America's few means for thinking about the unthinkable. The obliteration of life on earth was paralleled by the destruction of personal identity. A *Twilight Zone* identity crisis could be inspiredly hyperbolic, and the series was rife with sympathetic portrayals of dreamers and dropouts. In the haunting "Walking Distance" (10/30/59), an unhappy thirty-six-year-old advertising executive—Serling

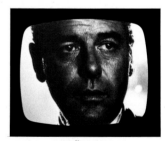
Gig Young in "Walking Distance"

was then thirty-five—seeks refuge from the rat race in the past in his boyhood town, "Homewood." The surprisingly grim "A Stop at Willoughby" (5/6/60) featured an even more frazzled adman, age thirty-eight, regressing further and failing to resurface altogether. Charles Beaumont's

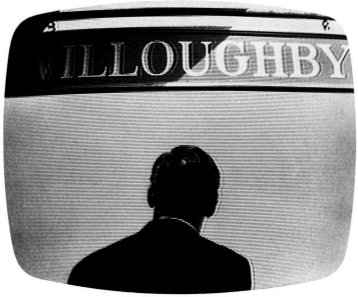

"A Stop at Willoughby"

"Perchance to Dream" (11/27/59), a taut, vivid half hour—as cannily atmospheric as vintage film noir—is played out in a psychiatrist's office. The hero, another thirty-five-year-old neurotic, has been suffering a recurring nightmare, and, driven mad by the projection of his untrammeled libido (sensationally visualized as a nocturnal amusement park), he takes a swan dive out the window.

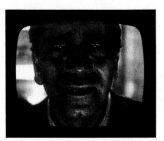

Richard Conte in "Perchance to Dream"

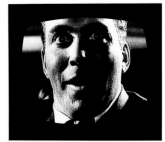

William Shatner in
"Nightmare at 20,000 Feet"

*The Twilight Zone* staged some of the best nervous breakdowns in TV history, two of them occurring just before CBS pulled the plug on the show.[2] Richard Matheson's classic "Nightmare at 20,000 Feet" (10/11/63) plays on a half-dozen barely articulated anxieties (fear of flying, of madness, of betrayal by a spouse), as William Shatner—who had already demonstrated a flare for obsessive-compulsive behavior as the superstitious honeymooner in "Nick of Time" (11/18/60)—hallucinates a gremlin on the wing of a jetliner. Once seen, this show can never be forgotten; Shatner's freak-out displays a range (and a knack for comedy) that he seems to have lost on his first *Star Trek*.

The real chill in "Nightmare . . ." is in the force of the protagonist's delusion. The same is true for "Living Doll" (11/1/63), where irascible Telly Savalas imagines that he's being threatened by his stepdaughter's favorite toy. In both cases, the perfunctory revelation that the delusions

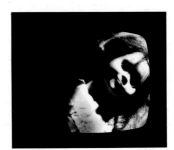

"Living Doll"

are real—actually supernatural—has about as much weight as the conventional happy ending of a Douglas Sirk melodrama.

[2]After three seasons in the Friday 10 p.m. time slot, *The Twilight Zone* was canceled in 1962, but returned in January 1963 on Thursday nights at 9 p.m., in a new, hour-long format. In the series' final season, it was cut back to thirty minutes and restored to Friday night at 9:30 as the lead-in for the expanded *Alfred Hitchcock Hour*.

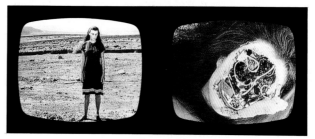

Jean Marsh in "The Lonely"

ike most television, *The Twilight Zone* was often silly and hackneyed, over-reliant on corny costume stories and simpleminded morality plays. But its two-score strongest offerings followed the trajectory of the archetypal German Expressionist scenario in which "one went from a mindless state of middle-class respectability, in which one's physical environment was taken for granted and things were veiled in a socially acceptable way of reflex seeing, to the horrifying realization that things are not what they seem, that they are threatening and demonic, to end with an ecstatic and explosive breakthrough to their ultimate essence."[3]

As did the German silent cinema, *The Twilight Zone* exhibited a profound, anxious preoccupation with the nature of the self. The series is rife with kindred motifs—doppelgängers, nightmares, malignant objects. Like the

"Nick of Time"

ridiculously bobbing devil's head in "Nick of Time," they herald the ascendance of irrational powers. The confusion of people with mannequins is among the series' favorite devices, almost the basis of *Twilight Zone* irony. When the hero of "The Lonely" (11/11/59) knowingly falls for a robot, he shows a rare degree of self-awareness. The protagonists of "The Lateness of the Hour" (12/2/60) and "In His Image" (1/3/63) are both surprised to find themselves androids.

[3]Barlowe, John D. *German Expressionist Film* (Twayne Publishers, Boston: 1982), p. 136.

*I* is literally an *other* in "Mirror Image" (2/26/60), which has Vera Miles plagued and ultimately supplanted by a mysterious double. Miles is trapped in an upstate New York bus depot as characterless and menacing as the southwestern motel that would swallow her "sister" Janet Leigh later that year in *Psycho*. Role-playing got the theater of the absurd treatment in Matheson's sardonic "A World of Difference" (3/11/60): The

Vera Miles

unfortunate protagonist unexpectedly hears a cosmic director call "Cut!" and discovers that his ordinary reality has been transformed into a giant movie set.

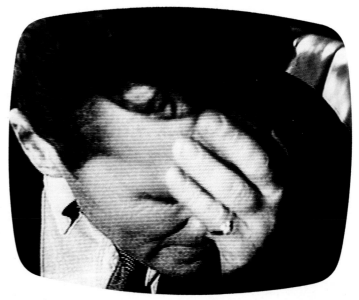

Howard Duff in "A World of Difference"

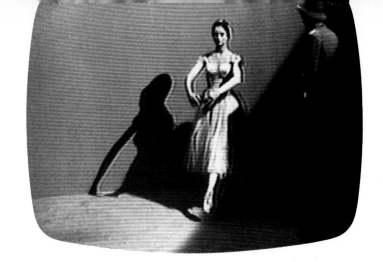

Mirror Image"

The elaborate "Five Characters in Search of an Exit" (12/22/61) offers *The Twilight Zone*'s ultimate existential situation. As denuded as a college production of an Off-Off-Broadway play, the show consists of a blank, characterless set mysteriously imprisoning a soldier, a clown, a ballet dancer, a hobo, and a bagpipe player, everyone banging on the wall and loudly wondering "Where are we? What are we? Who are we?" Although their fate is not unlike that of ventriloquist Cliff Robertson at the conclusion of "The Dummy" (5/4/62), the eerie sense is that these creatures are trapped inside the TV set.

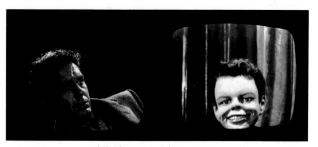

Cliff Robertson in "The Dummy"

"Five Characters in Search of an Exit"

Dick York in
"A Penny For Your Thoughts"

This generic surrealism became part of television's stock-in-trade, and by trafficking in it, *The Twilight Zone* anticipated much 1960s TV—even as the series' insistence on black and white rendered it obsolete in the context of the networks' great leap forward to color television. *The Twilight Zone* not only inspired a new wave of anthologies of the supernatural (*Thriller, Way Out, The Outer Limits*) but

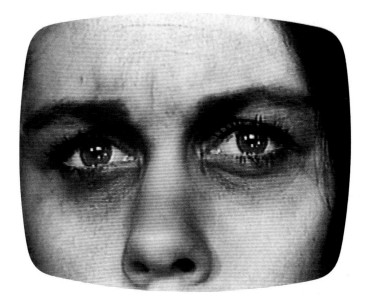

Elizabeth Montgomery in "Two"

created a context for the fantastic sitcoms (*My Favorite Martian, The Munsters, The Addams Family, My Living Doll, Bewitched, My Mother the Car, I Dream of Jeannie*) and "kitchen magician" commercials, which, by the middle of the decade, were dosing America's living rooms like bourgeois LSD.

Agnes Moorehead in
"The Invaders"

As the original "high concept" series, *The Twilight Zone* has remained a treasure trove of movie ideas. Dealing as they do with time travel, robot love, and the transmigration of souls, many 1980s comedies, ranging from Francis Ford Coppola's *Peggy Sue Got Married* to Susan Seidelman's *Making Mr. Right* to Penny Marshall's *Big*, suggest expanded *Twilight Zone* episodes. Indeed, *The Twilight Zone* legacy is so pervasive as to be almost invisible. Martin Scorsese appropriated a *Twilight Zone* title for his appropriately Kafkaesque *After Hours*; Woody Allen's *Zelig* and *The Purple Rose of Cairo* are anticipated by "The Four of Us Are Dying" (1/1/60) and "The Sixteen-Millimeter Shrine" (10/23/59). David Lynch seems to operate out of his personal twilight zone. Documentary filmmaker Errol Morris described *The Thin Blue Line*, his 1987 account of miscarried justice, as a "real-life *Twilight Zone* episode."

But the series seems to have left its most lasting effect on Steven Spielberg, who got an early break directing an episode of *Serling's Night Gallery* (NBC, 1970–73) and scored an early coup with *Duel*, an extremely effective 1971 telefilm based on Richard Matheson's highly Zoneesque script. The shark motif from *Jaws* is a riff on *The Twilight Zone* theme, and such Spielberg productions as *Back to the Future* and, particularly, *Poltergeist* are basically expanded *Twilight Zone* episodes—the latter suggesting an elaboration of Matheson's "Little Girl Lost" (3/16/62) in which

"Little Girl Lost"

a five-year-old child wanders through the wall of her suburban bedroom into another dimension. *Amazing Stories* (NBC, 1985–87), Spielberg's short-lived television series, was clearly in the *Twilight Zone* tradition, and even *Big* was written by

Spielberg's younger sister, Anne. And, of course, Spielberg coproduced *Twilight Zone—The Movie* (1983), along with John Landis. Landis, too, has employed a number of *Twilight Zone* motifs, including the use of the empty sets in *Into the Night* and the premise of *The Three Amigos*, which, in plunging movie cowboys into the "real" West, strongly suggests "Showdown with Rance McGrew" (2/2/62).

"The Four of Us Are Dying"

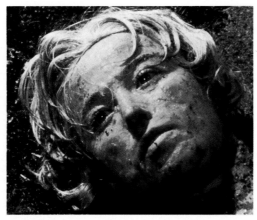

"Five Characters in Search of an Exit"

Cindy Sherman. *Untitled*, 1985.

Beyond the self-conscious recapitulation of plots, however, *The Twilight Zone* seems to have affected the sensibilities of certain American postmodern artists who saw the show while they were growing up and, albeit from a more dead-pan and ironic stance, echo the *Twilight Zone* preoccupation with loss of individual identity. The studied, barren stylizations of Cindy Sherman's uncannily anonymous self-portrait photographs evoke something of *The Twilight Zone*'s demonic "normality." Laurie Anderson's and David Byrne's alienated lyrics occasionally suggest more stringent versions of Serling's earnest introductions.

No less than Serling, these artists are deeply concerned with television—but from the perspective of consumer rather than creator. They satirize, rather than decry, the pleasures of conformity, as well as TV's invasive construction of a depersonalized "consumer self," defined and dissolved in the endless flux of advertising slogans and fetishized commodities. For them, *The Twilight Zone* is part of the landscape.

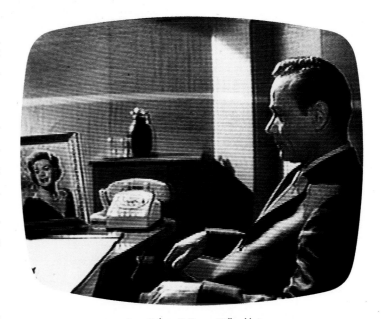
James Daly in "A Stop at Willoughby"

And you may find yourself
in a beautiful house,
with a beautiful wife.
And you may ask yourself,
"Well, how did I get here?"

"Once in a Lifetime" lyrics by David Byrne
and The Talking Heads

159

Though *The Twilight Zone* became a household phrase, the series itself, ironically, was always more a succès d'estime than a popular hit. In not one of its five seasons did the program finish in the Nielsen's top twenty-five. Initially clobbered in the ratings by *The Gillette Cavalcade of Sports*, later dismembered by *Dr. Kildare* and swamped by *McHale's Navy*, *The Twilight Zone* always found it easier to attract critical accolades than a regular sponsor. Among other things, the series was an alternative to the influx of TV Westerns that peaked between 1958 and 1960 and, as such, provided unusual dramatic opportunities. *The Twilight Zone* won consecutive Emmies for its writing in 1960 and 1961, and was even favorably cited by TV's toughest critic, Federal Communications Commission chairman Newton Minow, still remembered for his geographic coinage of 1961, the characterization of network television as a "vast wasteland."

*The Twilight Zone* was more than an oasis in the wasteland. At its best, it infused network television with a surprising degree of moral ambiguity; perhaps its greatest legacy was the sense of skepticism the series inspired in its viewers. *The Twilight Zone* was far less positivist than the crusading series *The Defenders* (CBS, 1961–65) and *East Side, West Side* (CBS, 1963–64), which replaced it as Emmy fodder. For all its ritual obeisance to the future and its recurring bouts of sentimentality, *The Twilight Zone* was remarkably downbeat. If the series was didactic, the single most pervasive lesson that Serling taught was the relativity of value: "Just how normal are we? Just who are the people we nod our hellos to as we pass on the street?" are the queries with which one episode ends.

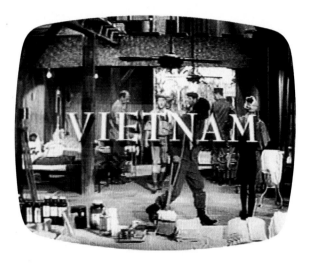

*My kid is dying in a place called South Vietnam*
*There isn't even supposed to be a war going on there*

"In Praise of Pip"

By the series' final season, however, reality had begun to exceed *Twilight Zone* weirdness. It's appropriate that an early television reference to American casualties in the undeclared war in Vietnam appeared in one of the series' last programs, "In Praise of Pip" (9/27/63). Less than two months later, the assassination of JFK would send the U.S. on a ten-year trip through a zone altogether more delirious and disorienting than even that mapped by Rod Serling.

*J. Hoberman writes film criticism for* The Village Voice.

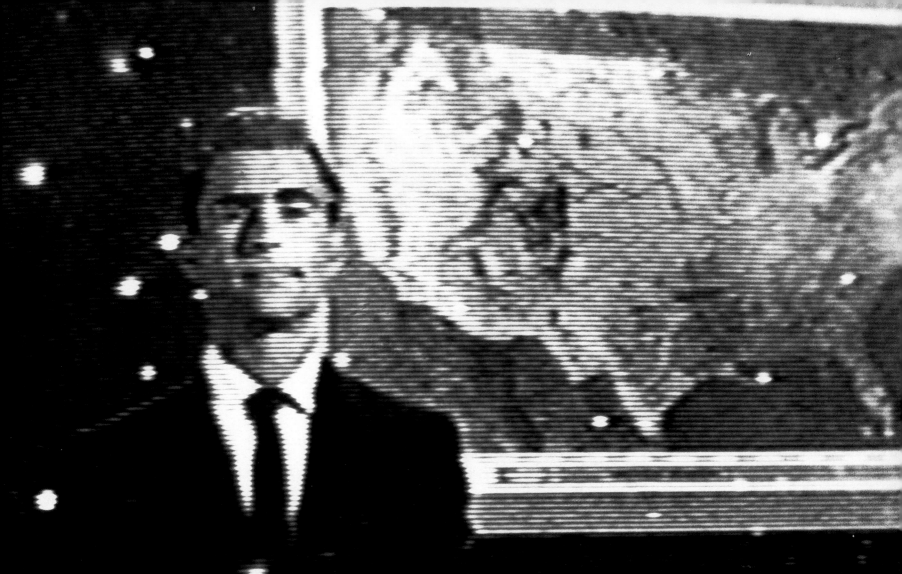

As long as people talk about you, you're not really dead
As long as they speak your name, you continue
A legend doesn't die just because the man does

Rod was, in his own words, "unabashedly and admittedly an admirer of fantasy and horror tales." He often described himself as being in a state of "willing suspension of disbelief." His library was full of books by Poe and Lovecraft, Shelley and James, and work by their "great-grandchildren" published in *Fantasy and Science Fiction*, *Galaxy*, and *If*.

Commenting at one point on commercials, he said, "How in God's name can you sustain a theatrical mood when every twelve minutes the thrust of the drama is stopped and onto the screen gallop twelve dancing rabbits with toilet paper? That TV has been able to achieve some of its more resplendent moments is a tribute to the resilience of artistic man surviving in a detergent jungle."

For Rod, fascination with the genre may well have been one reason for the birth of *The Twilight Zone*, but most certainly the other was frustration with television censorship. In remembering those TV times, Rod said that "the writer was hamstrung by the timorous taboos thrown at him by the various panjandrums who thought of 'entertainment' as a synonym for 'non-controversy.'" Racism, sexism, nuclear holocaust, politics, prejudice, or any issue of social significance was to be avoided at all costs.

*"My future is unquestionably in TV.*
*Television is much more intimate.*
*You're looking at people*
*close up, both physically and psychologically."*
—Rod Serling, 1955

"The Monsters Are Due on Maple Street" (3/4/60)

Many of the "golden boys" of early TV drama left the arena feeling that there was no real dramatic proscenium left for the serious writer, but Rod stayed around. He felt that television, the most immediate and dynamic of all the media, had the most potential to illuminate, educate, and inform.

Rod was aware of the philosophical limitations of television and accepted the fundamental fact that the TV economy, geared to advertising, had to ride piggyback on the commercial product. That isn't to say he totally accepted it.

He never underestimated the TV audience or aimed at the lowest common denominator. He often chastised the viewing public that seemed to prefer being "diddled to death and made to laugh" rather than educated or compelled to think. He prompted both the artist and the audience to maintain a sense of perspective when it came to television, reminding them that it was there to bring a fragment of life, a portion of the human experience, just an evening's

look at the human condition—not only man's frolics but his foibles and his faults.

So…thirty years ago, Rod stepped into *The Twilight Zone*. There, through parable and allusion, he could make social comment and confront issues. His avuncular presence calmed the viewer while suggesting that there were things in the world that needed a course correction. At one point he said, "There are things that scream for a response, and if we don't listen to that scream, and if we don't respond to it, we may well wind up sitting amidst our own rubble, looking for the truck that hit us, or the bomb that pulverized us. Get the license number of whatever it was that destroyed that dream and I think we may find that the vehicle was registered in our own name."

Speaking in the phraseology of fantasy and within the perimeters of his own show—it was the only time in his TV career that he had complete creative control—Rod could comment allegorically on universal themes. He used to say, "The story wears a different costume, has a different take, but the act is the same." The TV censors left him alone, either because they didn't understand what he was doing or believed that he was truly in outer space.

People often query me about Rod: Was he weird? The truth, though it may disappoint some of you, is that he wasn't. He was just as fearful of cemeteries at night and creaks in the attic as the next guy, and his favorite pastimes were the most mundane of pleasures: planting tomatoes, tending roses, building model airplanes, politics watching, bridge, and boating.

When Rod looked back over the *Twilight Zone* years, he commented, "We had some real turkeys, some fair ones, and some shows that I'm really proud to have been a part of." The experience was definitely a labor of love for almost all who worked on the series. The other writers, the actors, and the technicians were not only consummately skilled, but everyone felt excited and positive about the work they were doing.

*The Twilight Zone* has continued to play on TV screens somewhere in the world for all these years. My guess is that no one would be more surprised than Rod with the influence and lasting quality of the series. *The Twilight Zone* was a five-year "trip" for him, and when it went off the air, he sold the series to CBS and put it behind him, never dreaming that it would continue to have a life of its own and play to his grandchildren's generation.

Rod never considered himself the time's translator of the mystique, or the master guru of the genre, but every writer worthy of the name has something to say, and for a time, this particular hemisphere was his.

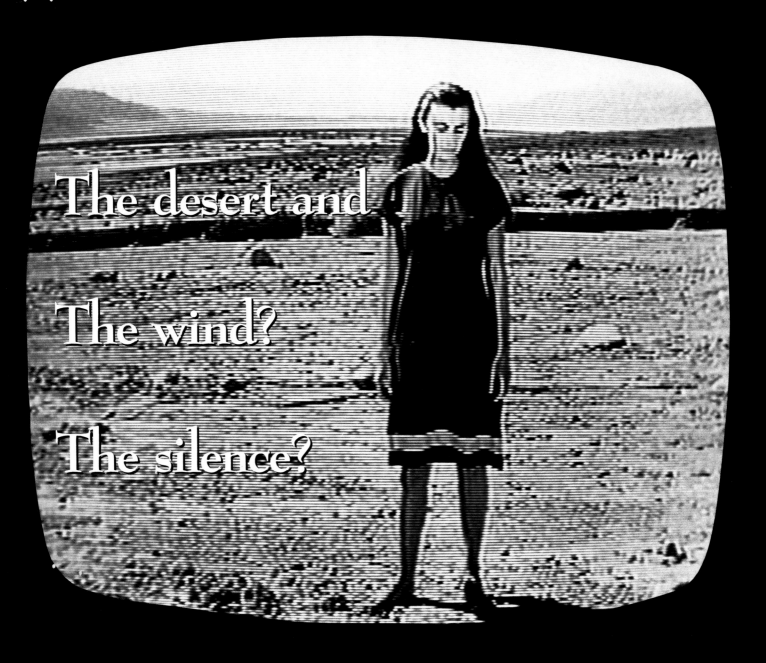

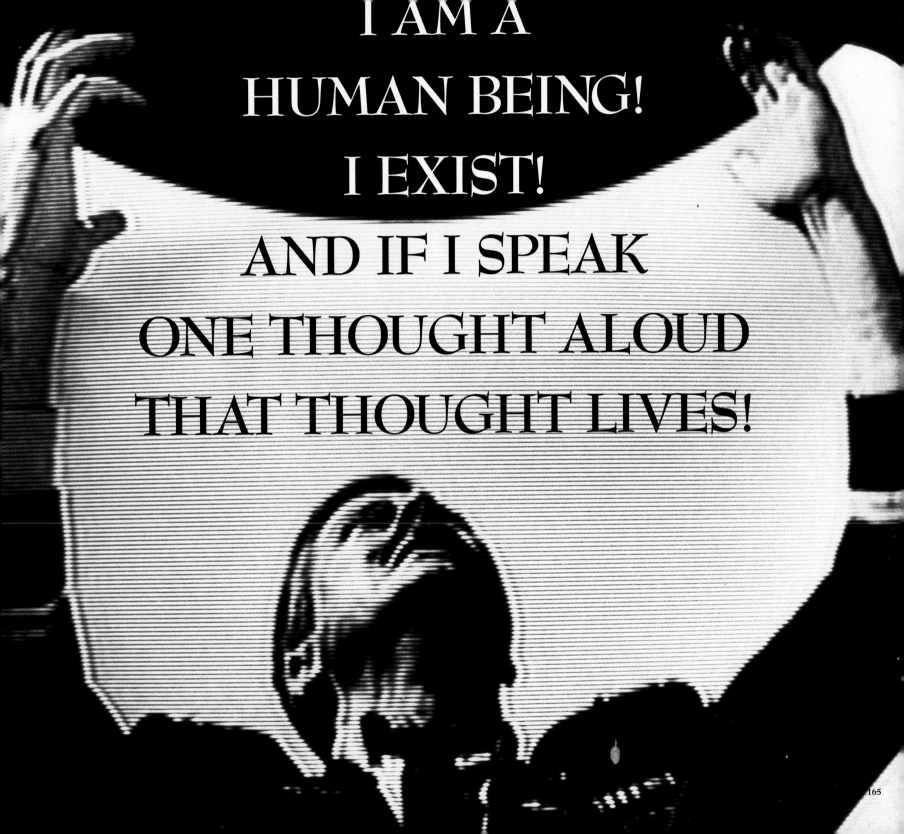

These men wrote
about life and
about the dignity of
the human spirit
and about love
The strange and
wondrous mysticism
that is a simple
act of living

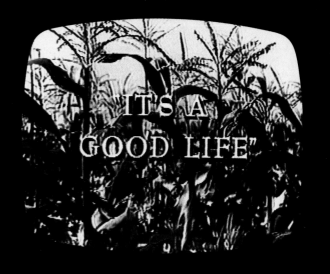

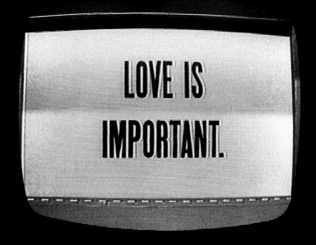

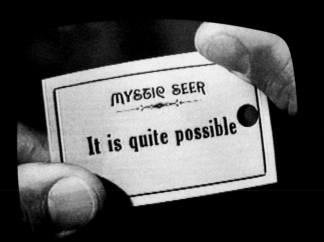

TRUTH IS OUR DOGMA

WE BELIEVE IT TO BE

MAN'S GREATEST WEAPON

AGAINST THE DEVIL

WHO IS THE FATHER

OF ALL LIES

ACCORDING
TO THE BIBLE
GOD CREATED THE
HEAVENS AND
THE EARTH

*It is man's prerogative—and woman's—to create their own particular and private hell.*

SOMEWHERE

IN BETWEEN HEAVEN

THE SKY

THE EARTH

LIES...

# EPISODE CREDITS

Credits are listed below images in the following order: show title, date of original broadcast, featured actor, writer and director (unless indicated, director of photography was George T. Clemens).

Text credits are listed below italic quotes in the following order: show title, date of original broadcast and writer.

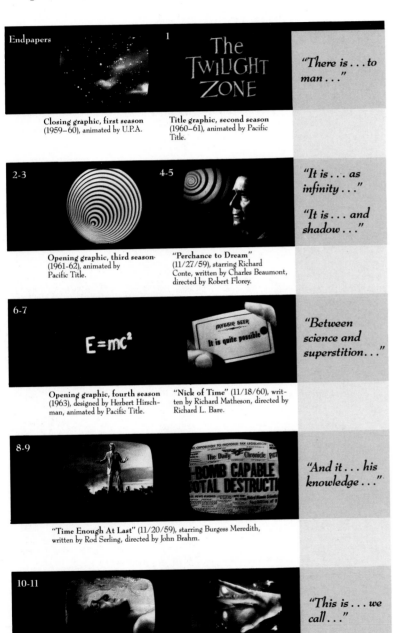

**Endpapers** / **1**

*"There is . . . to man . . ."*

Closing graphic, first season (1959–60), animated by U.P.A.

Title graphic, second season (1960–61), animated by Pacific Title.

**2-3** / **4-5**

*"It is . . . as infinity . . ."*

*"It is . . . and shadow . . ."*

Opening graphic, third season (1961-62), animated by Pacific Title.

"Perchance to Dream" (11/27/59), starring Richard Conte, written by Charles Beaumont, directed by Robert Florey.

**6-7**

$E = mc^2$

*"Between science and superstition . . ."*

Opening graphic, fourth season (1963), designed by Herbert Hirschman, animated by Pacific Title.

"Nick of Time" (11/18/60), written by Richard Matheson, directed by Richard L. Bare.

**8-9**

*"And it . . . his knowledge . . ."*

"Time Enough At Last" (11/20/59), starring Burgess Meredith, written by Rod Serling, directed by John Brahm.

**10-11**

*"This is . . . we call . . ."*

"The Long Morrow" (1/10/64), starring Robert Lansing, written by Rod Serling, directed by Robert Florey.

"Little Girl Lost" (3/16/62), written by Richard Matheson, directed by Paul Stewart.

From opening narration, first season (1959–60), written by Rod Serling.

**12-13**

"I Sing the Body Electric" (5/18/62), written by Ray Bradbury, directed by James Sheldon and William Claxton.

Opening graphic, fourth season (1963), designed by Herbert Hirschman, animated by Pacific Title.

**14-15**

Opening graphic, fourth season (1963), designed by Herbert Hirschman, animated by Pacific Title.

"The Chaser" (5/13/60), written by Robert Presnell, Jr., directed by Douglas Heyes.

**16-17**

Opening graphic, first season (1960 only), animated by Pacific Title.

**18-19**

"Where Is Everybody?" (10/2/59), written by Rod Serling, directed by Robert Stevens. (Director of photography: Joseph La Shelle.)

Page 19, clockwise from top left:

"The Lonely" (11/13/59), written by Rod Serling, directed by Jack Smight.

"Third from the Sun" (1/8/60), written by Rod Serling, directed by Richard L. Bare. (Director of photography: Harry Wild.)

"The Fever" (1/29/60), written by Rod Serling, directed by Robert Florey.

"The After Hours" (6/10/60), written by Rod Serling, directed by Douglas Heyes.

"A Passage for Trumpet" (5/20/60), featuring John Anderson, written by Rod Serling, directed by Douglas Heyes.

"The Obsolete Man" (6/2/61), written by Rod Serling, directed by Elliot Silverstein.

**20-21**

"The Obsolete Man" (6/2/61), written by Rod Serling, directed by Elliot Silverstein.

Page 20, clockwise from top left:

"A Stop at Willoughby" (5/6/60), starring James Daly, written by Rod Serling, directed by Robert Parrish.

"Mr. Denton on Doomsday" (10/16/59), starring Dan Duryea, written by Rod Serling, directed by Allen Reisner.

"The Little People" (3/30/62), written by Rod Serling, directed by William Claxton.

"Steel" (10/4/63), written by Richard Matheson, directed by Don Weis. (Makeup by William Tuttle.)

"Hocus-Pocus and Frisby" (4/13/62), written by Rod Serling, directed by Lamont Johnson. (Makeup by William Tuttle.)

"The Purple Testament" (2/12/60), written by Rod Serling, directed by Richard L. Bare.

**22-23**

Opening graphic, first season (1959–60), animated by U.P.A.

"A Thing About Machines" (10/28/60), written by Rod Serling, directed by David Orrick McDearmon.

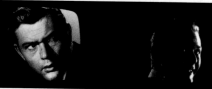

**24-25**

*"The place . . . is now . . ."*

Title graphic, first season (1959–60), animated by U.P.A.

**26-27**

*"It was . . . real, too"*

*"And the . . . our journey"*

"Perchance to Dream" (11/27/59), written by Charles Beaumont, directed by Robert Florey.

"Where Is Everybody?" (10/2/59), written by Rod Serling.

**28-29**

*"Where are . . . are we?"*

*"You're in . . . the shadow"*

"Five Characters In Search of an Exit" (12/22/61), written by Rod Serling, directed by Lamont Johnson.

"A Passage for Trumpet" (5/20/60), written by Rod Serling.

**30-31**

*"We exist . . . human beings?"*

"The After Hours" (6/10/60), starring Anne Francis, written by Rod Serling, directed by Douglas Heyes.

"Shadow Play" (5/5/61), written by Charles Beaumont.

**32-33**

*"I'm Talky . . . kill you!"*

*"How can . . . of wood?"*

Opening graphic, fourth season (1963), designed by Herbert Hirschman, animated by Pacific Title.

"Living Doll" (11/1/63), written by Jerry Sohl, directed by Richard C. Sarafian. (Director of photography: Robert Pittack)

"The Dummy" (5/4/62), written by Rod Serling.

**34-35**

*"Fictional characters . . . their own . . ."*

*"A playwright . . . whole story"*

"The Dummy" (5/4/62), starring Cliff Robertson, written by Rod Serling, directed by Abner Biberman. (Dummy designed by Frank Campbell.)

"A World of His Own" (7/1/60), written by Richard Matheson.

**36-37**

*"I've been . . . can live"*

*"I'm your . . . alter ego"*

"Mirror Image" (2/26/60), featuring Martin Milner, written by Rod Serling, directed by John Brahm.

"The Last Night of a Jockey" (10/25/63), written by Rod Serling.

**38-39**

*"We have . . . keep hidden"*

"Five Characters In Search of an Exit" (12/22/61), featuring Murray Matheson, written by Rod Serling, directed by Lamont Johnson.

"Nothing in the Dark" (1/5/62), featuring Robert Redford, written by George Clayton Johnson, directed by Lamont Johnson.

"A Piano in the House" (2/16/62), written by Earl Hamner, Jr.

**40-41**

*"Just how . . . the street?"*

"Mirror Image" (2/26/60), featuring Vera Miles, written by Rod Serling, directed by John Brahm.

"The Mind and the Matter" (5/12/61), written by Rod Serling, directed by Buzz Kulik. (Makeup by William Tuttle.)

"The After Hours" (6/10/60), written by Rod Serling.

**42-43**

*"People, they're . . . are alike"*

"The Big Tall Wish" (4/8/60), featuring Charles Horvath(l.) and Ivan Dixon(r.), written by Rod Serling, directed by Ron Winston.

"People Are Alike All Over" (3/25/60), written by Rod Serling.

**44-45**

*"Is that . . . being nobody?"*

"The Obsolete Man" (6/2/61), written by Rod Serling, directed by Elliot Silverstein.

"Number Twelve Looks Just Like You" (1/24/64), written by John Tomerlin.

**46-47**

*"Life is . . . is one"*

*"When everyone . . . no beauty"*

*"You're caricatures . . . you're caricatures!"*

"Number Twelve Looks Just Like You" (1/24/64), featuring Pam Austin, written by John Tomerlin, directed by Abner Biberman. (Director of photography: Charles Wheeler)

"The Masks" (3/20/64), written by Rod Serling, directed by Ida Lupino. (Makeup by William Tuttle.)

"Number Twelve Looks Just Like You" (1/24/64), written by John Tomerlin.

"The Masks" (3/20/64), written by Rod Serling.

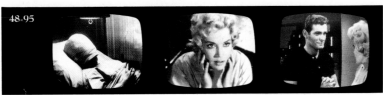

**48-95**

"The Eye of the Beholder" (11/11/60), featuring Maxine Stuart (left), Donna Douglas (center), and Edson Stroll (right), written by Rod Serling, directed by Douglas Heyes.

**96-97**

"I Sing the Body Electric" (5/18/62), written by Ray Bradbury, directed by James Sheldon and William Claxton.

Opening graphic, fourth season (1963), designed by Herbert Hirschman, animated by Pacific Title.

*"Beauty is . . . Twilight Zone"*

"The Eye of the Beholder" (11/11/60), written by Rod Serling.

**98-99**

Opening graphic, fourth season (1963), designed by Herbert Hirschman, animated by Pacific Title.

**100-101**

"People Are Alike All Over" (3/25/60), written by Rod Serling, directed by Mitchell Leisen.

*"Earth, it's . . . own master"*

"On Thursday We Leave for Home" (5/2/63), written by Rod Serling

**102-103**

"The Arrival" (9/22/61), written by Rod Serling, directed by Boris Sagal.

"The Monsters Are Due on Maple Street" (3/4/60), written by Rod Serling, directed by Ron Winston.

*"Some people . . . him apart"*

"A Stop at Willoughby" (5/6/60), written by Rod Serling.

**104-105**

"A Stop at Willoughby" (5/6/60), starring James Daly, written by Rod Serling, directed by Robert Parrish.

"A World of Difference" (3/11/60), starring Howard Duff, written by Richard Matheson, directed by Ted Post.

*"Sometimes I'd . . . simpler existence"*

*"Handsome, . . . idyllic?"*

"The Bewitchin' Pool" (6/19/64), written by Earl Hamner, Jr.

*"If you're . . . a nightmare"*

"Shadow Play" (5/5/61), written by Charles Beaumont.

**106-107**

"A Stop at Willoughby" (5/6/60), starring James Daly, written by Rod Serling, directed by Robert Parrish.

"Walking Distance" (10/30/59), written by Rod Serling.

*"I'd been . . . and listen"*

*"Beautiful these . . . no past"*

"A Penny for Your Thoughts" (2/3/61), written by George Clayton Johnson.

**108-109**

"What You Need" (12/25/59), written by Rod Serling, directed by Alvin Ganzer.

"The Hitch-Hiker" (1/22/60), starring Inger Stevens, written by Rod Serling, directed by Alvin Ganzer.

*"That's the . . . up ahead"*

From opening narration, second season (1960–61), written by Rod Serling

*"We are all travelers . . ."*

**110-111**

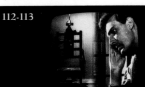

"The Four of Us Are Dying" (1/1/60), written by Rod Serling, directed by John Brahm. "

"The Hitch-Hiker" (1/22/60), starring Inger Stevens, written by Rod Serling, directed by Alvin Ganzer.

*"The trip . . . called death"*

"Ring-a-Ding Girl" (12/27/63), written by Earl Hamner, Jr.

*"Room for one more"*

"Twenty-Two" (2/10/61), written by Rod Serling

**112-113**

"Shadow Play" (5/5/61), starring Dennis Weaver, written by Charles Beaumont, directed by John Brahm.

*"Every man . . . execution unknown"*

"Escape Clause" (11/6/59), written by Rod Serling.

**114-115**

"The Obsolete Man" (6/2/61), written by Rod Serling, directed by Elliot Silverstein.

*"This is . . . and examined"*

"Judgment Night" (12/4/59), written by Rod Serling.

**116-117**

"The Four of Us Are Dying" (1/1/60), written by Rod Serling, directed by John Brahm.

*"Why does . . . to die? . . ."*

"Escape Clause" (11/6/59), written by Rod Serling.

*"The world . . . man's life? . . ."*

*"A handful . . . been born?"*

"Where Is Everybody?" (10/2/59), written by Rod Serling, directed by Robert Stevens.(Director of photography: Joseph La Shelle.)

*"Only if . . . at all"*

*"No man . . . the fullest"*

"Long Live Walter Jameson" (3/18/60), written by Charles Beaumont, directed by Anton Leader.

"Escape Clause" (11/6/59), written by Rod Serling.

"Ninety Years Without Slumbering" (12/20/63), written by Richard deRoy.

*"Clocks are . . . creates time"*

"A Kind of Stopwatch" (10/18/63), written by Rod Serling, directed by John Rich. (Director of photography: Robert Pittack.)

Opening graphic, fourth season (1963), designed by Herbert Hirschman, animated by Pacific Title.

"Ninety Years Without Slumbering" (12/20/63), written by Richard deRoy.

*"Each man . . . with fear"*

"Ninety Years Without Slumbering" (12/20/63), written by Richard deRoy.

Station identification graphic, fourth season (1963), designed by Herbert Hirschman.

"Walking Distance" (10/30/59), starring Gig Young, written by Rod Serling, directed by Robert Stevens.

*"And perhaps . . . man's mind"*

"Walking Distance" (10/30/59), written by Rod Serling.

*"At night . . . on living"*

"The Fever"-(1/29/60), starring Everett Sloane, written by Rod Serling, directed by Robert Florey.

"Perchance to Dream" (11/27/59), written by Charles Beaumont, directed by Robert Florey.

"Long Live Walter Jameson" (3/18/60) Written by Charles Beaumont.

*"An observation . . . frightened breed"*

"Perchance to Dream" (11/27/59), starring Richard Conte, written by Charles Beaumont, directed by Robert Florey.

"Probe 7—Over and Out"(11/29/63), written by Rod Serling.

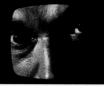

*"Being frightened . . . really counts"*

"A Penny for Your Thoughts" (2/3/61), written by George Clayton Johnson, directed by James Sheldon.

"Judgment Night" (12/4/59), starring Nehemiah Persoff, written by Rod Serling, directed by John Brahm.

"The Fear" (5/29/64), written by Rod Serling.

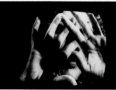

*"I don't . . . all away"*

"The Jungle" (12/1/61), written by Charles Beaumont, directed by William Claxton.

"The Big Tall Wish" (4/8/60), written by Rod Serling, directed by Ron Winston.

"The Sixteen-Millimeter Shrine" (10/23/59), written by Rod Serling.

*"How thin . . . a mind?"*

"Mirror Image" (2/26/60), written by Rod Serling.

"Perchance to Dream" (11/27/59), starring Richard Conte, written by Charles Beaumont, directed by Robert Florey.

"Nightmare at 20,000 Feet" (10/11/63), starring William Shatner, written by Richard Matheson, directed by Richard Donner. (Director of photography: Robert Pittack.)

*"The human . . . means salvation"*

"Nightmare As A Child"(4/29/60), written by Rod Serling.

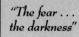

*"The fear . . . the darkness"*

"And When the Sky Was Opened" (12/11/59), starring Rod Taylor, written by Rod Serling, directed by Douglas Heyes.

"One More Pallbearer" (1/12/62), starring Joseph Wiseman, written by Rod Serling, directed by Lamont Johnson.

"The Hitch-Hiker" (1/22/60), written by Rod Serling.

*"I shot . . . of Space"*

"I Shot An Arrow Into the Air"(1/15/60), written by Rod Serling.

"Probe 7—Over and Out" (11/29/63), written by Rod Serling, directed by Ted Post. (Director of photography: Robert Pittack.)

"Third from the Sun" (1/8/60), written by Rod Serling, directed by Richard L. Bare. (Director of photography: Harry Wild.)

*"Up there . . . as isolation"*

"Where Is Everybody?" (10/2/59), written by Rod Serling.

*"As a . . . outer space"*

"The Invaders" (1/27/61), starring Agnes Moorehead, written by Richard Matheson, directed by Douglas Heyes.

"To Serve Man" (3/2/62), written by Rod Serling.

**142-143**

$$E = mc^2$$

Opening graphic, fourth season (1963), designed by Herbert Hirschman, animated by Pacific Title.

"People are . . . too late"

"Third from the Sun" (1/8/60), written by Rod Serling.

**144-145**

"Time Enough At Last" (11/20/59), written by Rod Serling, directed by John Brahm.

Station identification graphic, second season (1960–61), animated by Pacific Title.

"I remember . . . was right"

"On Thursday We Leave for Home" (5/2/63), written by Rod Serling.

**146-147**

"Shadow Play" (5/5/61), written by Charles Beaumont, directed by John Brahm.

**150**

"Where Is Everybody?" (10/2/59), written by Rod Serling, directed by Robert Stevens. (Director of photography: Joseph La Shelle.)

**161**

"It's a Good Life" (11/3/61), written by Rod Serling, directed by James Sheldon.

"As long . . . man does"

"A Game of Pool" (10/13/61), written by George Clayton Johnson.

**163**

"The Obsolete Man" (6/2/61), written by Rod Serling, directed by Elliot Silverstein.

**164-165**

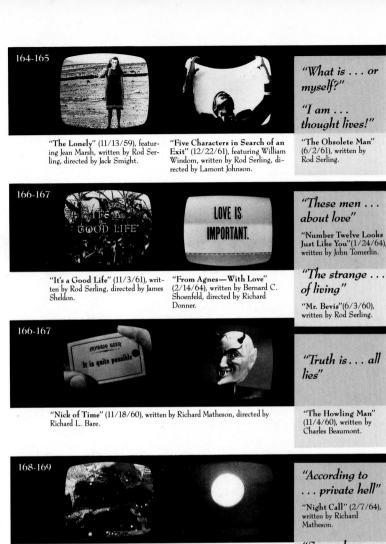

"The Lonely" (11/13/59), featuring Jean Marsh, written by Rod Serling, directed by Jack Smight.

"Five Characters in Search of an Exit" (12/22/61), featuring William Windom, written by Rod Serling, directed by Lamont Johnson.

"What is . . . or myself?"

"I am . . . thought lives!"

"The Obsolete Man" (6/2/61), written by Rod Serling.

**166-167**

"It's a Good Life" (11/3/61), written by Rod Serling, directed by James Sheldon.

"From Agnes—With Love" (2/14/64), written by Bernard C. Shoenfeld, directed by Richard Donner.

"These men . . . about love"

"Number Twelve Looks Just Like You" (1/24/64), written by John Tomerlin.

"The strange . . . of living"

"Mr. Bevis" (6/3/60), written by Rod Serling.

**166-167**

"Nick of Time" (11/18/60), written by Richard Matheson, directed by Richard L. Bare.

"Truth is . . . all lies"

"The Howling Man" (11/4/60), written by Charles Beaumont.

**168-169**

Opening graphic, first season (1959–60), animated by U.P.A.

Opening graphic, second season (1960–61), animated by Pacific Title.

"According to . . . private hell"

"Night Call" (2/7/64), written by Richard Matheson.

"Somewhere in . . . earth, lies . . ."

"The Last Flight" (2/5/60), written by Richard Matheson.

Station identification graphic, second season (1960–61), animated by Pacific Title.

Most of the *Twilight Zone* episodes covered in this book are available on home video, distributed by CBS Video Library, 51 West 52nd Street, New York, NY 10019; the Museum of Broadcasting in New York City has many episodes on file. For a complete overview of Rod Serling's work, consult the Serling Archives at Ithaca College, School of Communications, Ithaca, New York.

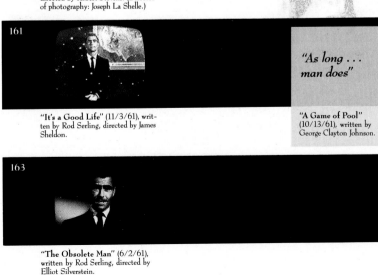

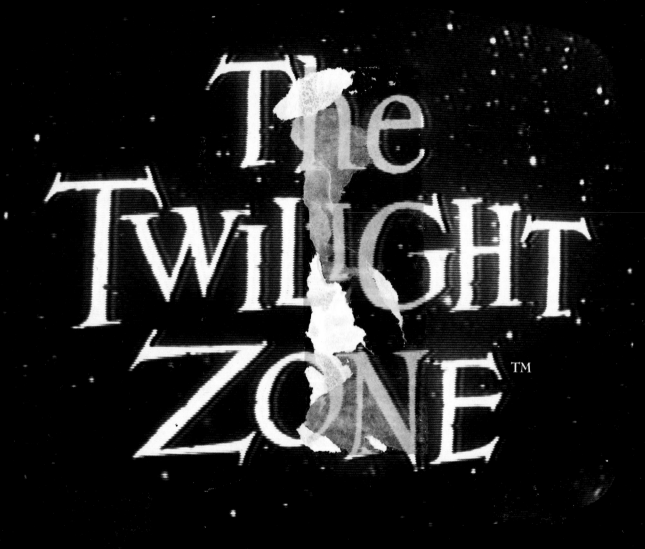

## ACKNOWLEDGEMENTS

To my mother, for providing, and my brother, for sharing, a wonderful childhood that included *The Twilight Zone*; my "Homewood," Fair Lawn; the ethics and values of Judaism; the wonderful world of comics; Quentin Fiore for *The Medium is the Massage*, Tom Ockerse for the concrete book, and David Reiss for his 1980 Rhode Island School of Design yearbook; Howard Berk at Viacom, and Carol Serling for nine years of support; my cousin Barbara at *TV Guide*, and Herma Rosenthal for her early written contribution; J. Hoberman for "Vulgar Modernism" (*Artforum*, February 1982); Lori Perkins, my agent, for believing in this book; my wife, Sherri, family and friends for believing in me; George Clemens, Doug Heyes, Buck Houghton, and Richard Matheson, for their generous time and hospitality; Marc Zicree for his gracious endorsement; Jim Markovic at Rainbow Video; Barbara Lowenstein and Associates; Steve Heller and the School of Visual Arts; Fearn Cutler at Pantheon Books; David Barich, Lisa Howard, Judith Dunham, and everyone at Chronicle Books; and my creative team, David O'Connor, Brian Sisco, Leah Lococo, Ann Harakawa, and Trufont Typographers, for helping me bring my vision to life.